IMAGES
*of America*

# BROOKLYN PARK AND BROOKLYN CENTER

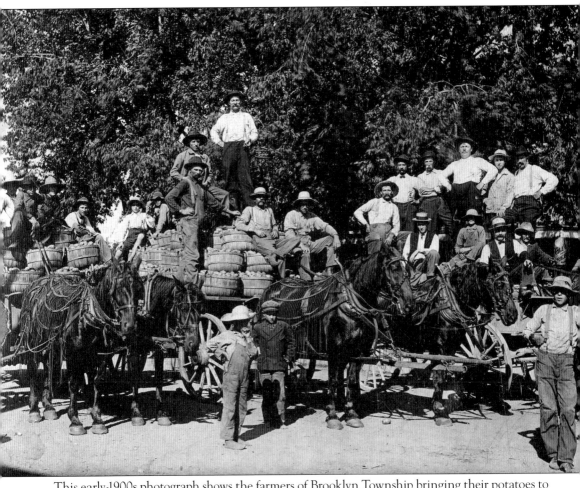

This early-1900s photograph shows the farmers of Brooklyn Township bringing their potatoes to Osseo to be weighed, sold, and shipped on a Northern Pacific Railway train. (Courtesy of Vera Schreiber/Brooklyn Historical Society.)

*On the cover*: Please see above. (Courtesy of Vera Schreiber/Brooklyn Historical Society.)

IMAGES
*of America*

# BROOKLYN PARK AND
# BROOKLYN CENTER

*Dear Gwen & Mike*
*Thanks for a*
*wonderful evening with*
*Erica and the rest of the*
*family!*
*Pat Snodgrass*

Pat Snodgrass

ARCADIA
PUBLISHING

Published by Arcadia Publishing
Charleston SC, Chicago IL, Portsmouth NH, San Francisco CA

Printed in the United States of America

Library of Congress Catalog Card Number: 2008932683

For all general information contact Arcadia Publishing at:
Telephone 843-853-2070
Fax 843-853-0044
E-mail sales@arcadiapublishing.com
For customer service and orders:
Toll-Free 1-888-313-2665

Visit us on the Internet at www.arcadiapublishing.com

*In honor of the Brooklyn settlers, historians, and my parents,*
*Leonard and Kathryn (Koch) Martens,*
*who passed on to me a passion for history*

# CONTENTS

# ACKNOWLEDGMENTS

The Brooklyn Historical Society has been blessed with a number of presidents, including Leone Howe, Mary Jane Gustafson, Jane Hallberg, Noreen Roberts, Ernie McArthur, and others, who have diligently researched, sought out photographs, and documented our history. Dozens of members contributed to a collection of biographies and histories that appeared in *The Brooklyns*, a book issued in 2002. Still others conducted oral interviews with city leaders and descendants of original settlers. The stories Eldon Tessman, Bill Schreiber, John Wingard, and many others recorded are valuable and helped put the puzzle pieces of history together. A deep debt is owed to the George Setzler, Vera Schreiber, Alice Tessman, Rose Sandholm, Pat Keefe Rice, and many other early families, who donated hundreds of photographs that wonderfully depict the life in a bygone era. Without these stories and photographs, it would be impossible to create a meaningful pictorial history of Brooklyn Park and Brooklyn Center. Neighboring historical societies have been generous with their collections. The Anoka County Historical Society and the Minnesota Historical Society preserved and provided several photographs of the Brooklyn area. The City of Osseo and Osseo Preservation Society generously shared their collection of photographs and *Osseo Press* and *Osseo Herald* newspapers from the early 1900s.

# INTRODUCTION

Just prior to the nation's bicentennial in 1976, the North Hennepin Pioneer Society preserved the early Isaac Potter cottage and formed the Brooklyn Historical Society. As a nonprofit organization dedicated to "research and provide access to historical information about the Brooklyn Township—yesterday, today, and tomorrow," Mary Jane Gustafson, Leone Howe, and Jane Hallberg began the task of documenting the history of Brooklyn Township and the cities of Brooklyn Center, Osseo, and Brooklyn Park that grew out of it. Throughout the 1980s, these three individuals collected photographs, stories, and published several books. Noreen Roberts continued the research into the 1990s, followed by Ernie McArthur, Tony Kiefler, and many others, who directed much of *The Brooklyns* in 2002.

While researching a three-volume set of books called *The Brooklyn Patriots: Suppressors of the Great Slaveholder Rebellion*, we were approached and asked whether anyone in the Brooklyn Historical Society would be interested in writing a pictorial history. Such an opportunity could not be turned down. Using numerous books, such as *The Brooklyns, The History of Brooklyn Centre, The History of the Earle Brown Farm, Growing Up on the Brooklyn Farm, Howe's Best Bet: The Life and Times of Roy and Myrtle Howe and Their Family, Pioneer Lendt (Lent) Family in Minnesota, The History of Minneapolis, Red River Trails, Old Rail Fence Corner, Pioneer Sketches, History of the Minnesota Valley*, and the *Osseo Herald* newspapers, I discovered a wealth of history that had not been published. More important, it is the numerous oral histories, stories, and vignettes of people that truly capture the history of Brooklyn Park and Brooklyn Center. Their stories along with preserved and treasured photographs bring to life the individuals who settled and developed the Brooklyn area.

Many historical books about Minnesota have given the history of explorers, such as Fr. Louis Hennepin, Zebulon Pike, and René-Robert Cavelier, Sieur de La Salle. Other histories go into details on the prehistoric history or unknown Native American tribes that traversed across the land. *Brooklyn Park and Brooklyn Center* is about the pioneers and settlers who came to Brooklyn Township and stayed. This is a story about not only the more notable people, but the many lesser-known people who served and led quiet lives. My goal was to capture the experience of individuals when automobiles were introduced as well as other technological advances. Most readers desire to know how people lived their lives—the clothes they wore, where they shopped, what they ate, what chores they performed, how much money they earned, and what they did during and after school. Every effort has been made to depict the everyday life of individuals over the past century and a half.

The first settlers came to northeastern Hennepin County in 1852, and Brooklyn Township was organized on May 11, 1858, the same day that Minnesota became a state. Brooklyn Park,

Osseo, and most of Brooklyn Center were included within the township along with several ghost towns, known as Palestine, Farmersville, City of Attraction, Industriana, Warwick, and Harrisburg, which quickly vanished. The New England families that stopped first in Adrian, Michigan, suggested that Brooklyn Township be named after Brooklyn, Michigan. Brooklyn was a train station the pioneers passed on their way to Minnesota. One suggested name was Jackson, after a town in Michigan that was "the worst place on earth." Another person claimed that "Crooked Brook" should be named for Shingle Creek's meandering path. A month after Brooklyn Township was incorporated, the officers determined Brooklyn Township was the most appropriate name.

Over the years, the Brooklyn farmers built up an expertise and a reputation, receiving acclaim for their potatoes and market gardening. The fertile acreage available, the huge pocket or underground source of water, called the Jordan vein of water, and the proximity to the Northern Pacific Railway and to Minneapolis also contributed to their success. Likewise, their location along the Mississippi River gave them a secondary occupation. Once the fields were set for winter, many farmers, laborers, and hired hands turned to the northern "pineries" and hired out to logging companies. While snow covered the fields, they became skilled loggers and earned additional wages to help provide for their families. Many others kept full-time jobs or ran their own businesses in Anoka, Osseo, and Minneapolis.

With ancestors that first settled in North America in the 1600s, the French Canadians and New Englanders came first to Brooklyn Township. Soon after, the Swiss, Germans, and Scandinavians came. Each group claimed a prairie, developed their farms and fields, built churches and one-room schoolhouses, and celebrated holidays and special events within their community. As students were educated beyond the eighth grade, they met others from the neighboring communities. Eventually the families from different nationalities married into other nationalities to form a community of farmers with many generations of shared family.

Since the Brooklyn area changed drastically during the post–World War II era, *Brooklyn Park and Brooklyn Center* covers the history prior to the 1950s. Hopefully, the Brooklyn Historical Society can begin to capture the oral history and photographs of newcomers and immigrants who settled more recently in the area. Both cities today have a rich, multicultural population with exciting stories to tell that will fill volumes of history in the future.

Brooklyn Township had the distinct status as a farming community with no downtown area. There were few stores and no main street. Early historian Isaac Atwater described the Brooklyn area as "an exclusively agricultural town." Three early Native American trails ran south to north through Brooklyn Township. These three trails eventually transformed into the three main roads of West River Road to the east, Osseo Road in the middle, which is now called Brooklyn Boulevard, and Jefferson Highway to the west, which is now called Bottineau Boulevard. Churches, schools, and a few stores were built along these roads. However, farmers traveled to nearby Osseo, Anoka, Champlin, Camden, and Minneapolis to work or conduct business. In the early 1900s, Brooklyn Center was organized as a village and city in order to escape being absorbed by Minneapolis. Brooklyn Park was organized in the 1950s to avoid being absorbed by Osseo. These cities had a distinct farming culture and a desire to preserve their differences. Minnesotans have long been known for their desire to stay close to home. This was definitely true of Brooklyn families. As recently as the 1950s, the majority had not traveled into another state. Although demographics continued to change, especially when the development and taxes of the 1970s forced farmers to sell their farms, many fourth- and fifth-generation families still live in Brooklyn Park, Brooklyn Center, or the neighboring suburbs. In 2008, a corn crop was harvested and a roadside stand continued selling fresh produce, which indicates the longevity of farming that began 156 years before.

# One

# EARLY SETTLERS, HOMES, AND TRAVEL

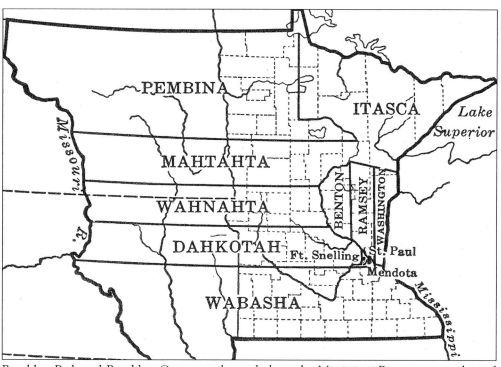

Brooklyn Park and Brooklyn Center are located along the Mississippi River, an area claimed for King Louis XIV of France in 1682. Eventually it came under Spanish rule followed by the District of Louisiana and territories of Missouri, Michigan, and Iowa. Finally on March 3, 1849, the Brooklyn area fell within the Minnesota Territory. The population was 4,680; however, no one had yet settled in the Brooklyn area. (Courtesy of *Minnesota: Its Geography, History, and Government.*)

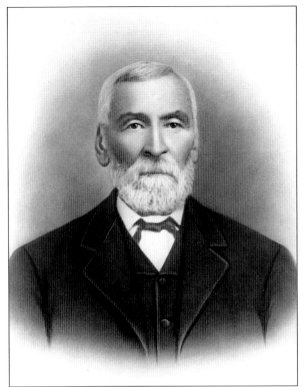

When the United States and the Dakota Indians signed the Treaty of Traverse des Sioux on July 23, 1851, the government paid $1.665 million and opened 19 million acres. Pierre Bottineau, who had Dakota Indian, Anishinabe Indian, and French ancestry, was an early settler in Brooklyn Township. As an explorer, scout, interpreter, and the father of over 20 children, he also founded St. Paul, St. Anthony, and Red Lake Falls. (Courtesy of Osseo Preservation Society.)

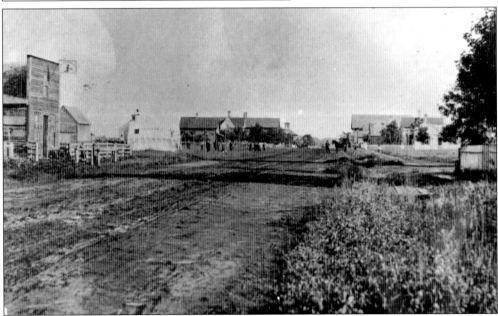

John Bour recalled that in 1869 Osseo (above) was where Brooklyn farmers came and was one of Minnesota's largest markets. "People would come in for miles around with ox teams loaded with . . . rags, some with hides and furs, some with wood, posts, and other forest products. . . . Rags were as good as gold in any trade. . . . Hundreds of yokes of cattle would be tied along the streets." St. Anthony merchants bought everything in sight. (Courtesy of Osseo Preservation Society.)

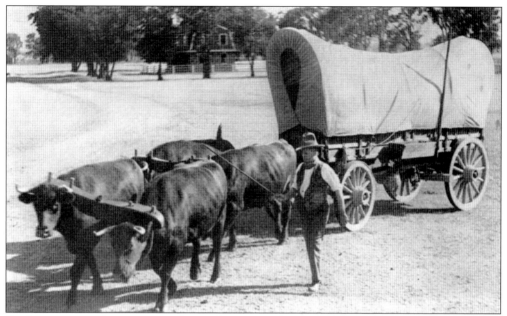

Settlers in covered wagons, similar to the wagon above owned by Earle Brown, poured into Minnesota to claim land. They preempted up to 160 acres at a cost of $1.25 per acre. Pioneers drove their stakes into the ground to indicate the boundaries of their property and erected cabins. When leaving a claim, a settler risked losing it to a claim jumper. (Courtesy of Earle Brown/Brooklyn Historical Society.)

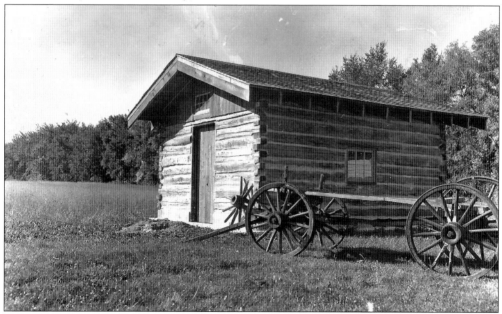

The rich Brooklyn land was snatched up in Getchell Prairie to the south, Jenkins Prairie to the southwest, Bottineau Prairie to the northwest, and Long Prairie, which ran on the north side along the Mississippi River. Shacks or small cabins like the Potter Log Cabin (above) were built on the claim. By 1855, the property was plotted, and pioneers settled up their claims. (Courtesy of Brooklyn Historical Society.)

French Canadians Pierre Bottineau, Joseph Potvin, Peter Raiche, and Louis Pierre Gervais came on July 1, 1852. They liked the beautiful prairie that gently sloped eastward to the Mississippi River. "Cele est Le Paradis," said Bottineau. Settlers from Little Canada, Pembina, and Quebec journeyed to Bottineau Prairie. Dissatisfied with Canada's desegregation, French Canadians wanted to preserve their language, religion, and culture. On July 1, 1859, Pres. James Buchanan signed Bottineau's deed. (Courtesy of Brooklyn Historical Society.)

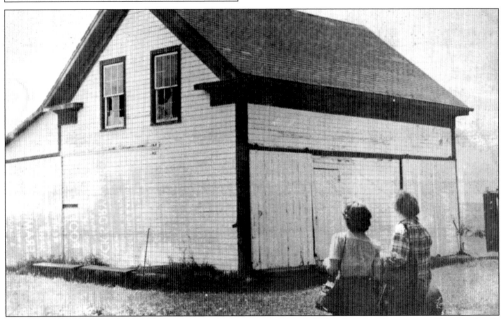

Jane Hallberg with Ruth Lind spearheaded preservation of the Pierre Bottineau House, built in 1854. The Greek Revival house had walls of a reddish-colored pine, hand-hewn beams, and siding and shingles made by hand with a draw-blade. Some individuals claimed Bottineau threw silver dollar bills into the Mississippi River to watch them skip, lost his Nicollet Island holdings in a poker game, and lit cigars with $10 bills. (Courtesy of Brooklyn Historical Society.)

For over 50 years, people of the Brooklyn Township were known as Yankees because of the large number of settlers who came from New England. In 1848, George Washington Getchell, with his son-in-law Amos Berry and grandson Jacob Longfellow, came from Maine. Although Getchell continued moving farther west, Getchell Prairie was named after him. Sylvanus Jenkins came from Vermont in 1851. His family joined him when he placed a claim on Jenkins Prairie in 1852. A year later, his brother Norman H. Jenkins joined him. That same year, 14 families came from Adrian, Michigan. This included W. W. Wales and Jonathan Estes followed by Samuel Howe, A. H. Benson, Charles Ward, Silas Merrill, John Dunning, R. L. Bennett, and Nathan Getchell in 1854. (Courtesy of *The Geology of Minnesota*.)

Mary A. Getchell spoke of her 1851 trip to Minnesota, "It took three long years to save money. . . . In those days it took a month to come. . . . One bright day in June an ox team drove to the door and took us and our baggage to Grandmother Longfellow and from there to the boat which left at 4 o'clock on Monday morning. We arrived in Boston Tuesday morning. . . . We took the train to Albany, N.Y. and from there by canal boat to Buffalo and steam boat to Chicago. There we hired a man and his team to drive us across the prairies of Illinois to Galena. Then from Galena we came by boat to St. Paul. We arrived at St. Anthony . . . and received a hearty welcome from my mothers people who had come here some three years before." St. Anthony is pictured here. (Courtesy of *The Geology of Minnesota*.)

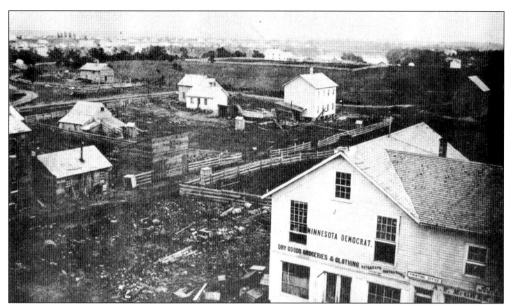

When Brooklyn was settled, three trails ran perpendicular to the Mississippi River. These had been used for hundreds of years as Native Americans moved between spring maple syrup harvesting to their fall wild rice harvesting and to the hunting grounds to the north during the winter. Mary (Smith) Pribble came by stagecoach to Brooklyn from St. Paul in the summer of 1853. Minneapolis (above) was bypassed as just a small settlement. (Courtesy of *Minneapolis: City of Opportunity.*)

After arriving in Anoka, the family took turns crossing the river in a small canoe to Charles Miles's trading post in Champlin. While her younger brothers accompanied her parents across the river, Pribble waited on the "east shore sitting upon our baggage" until her father returned for her. Once across the river, Native Americans gathered to greet the newcomers and exclaimed over her white skin. (Courtesy of *Red River Trails.*)

Frank O'Brien wrote of walking from St. Anthony to Brooklyn in about 1857, "The bus did not call for me at the door; nor was a train in waiting at the station to speed me on the way. Oh no! for there was not a railroad or station in this infant State. I grasped my shiny grip with my right hand; with my left I carried my comparatively new boots that were tied by the straps with a leather string and started barefoot for a seven-mile tramp over a dry and dusty road. Father had provided me with plenty of pocket money with which to defray my expenses on the way; this was five cents for the ferryman, Peter Poncin, to transfer me safely to the 'other shore' of the Mississippi. The ferry was near what is now Twentieth Avenue North." (Courtesy of *Red River Trails*.)

Joseph W. Duchene's homestead (above) near Seventy-second and Fremont Avenues was similar to Winslow Crooker's house, described by O'Brien as "a one-story structure, with two rooms, and a very small attic, access to which was gained by boards nailed for stairs to the studding, and leading up through a hole in the ceiling. This was my room . . . and later in the season, of seed corn, dried rings of pumpkins strung on a pole, bunches of sage, boneset and tansy. My bed was on the floor, as the roof hugged the floor so closely that the room would not admit of the luxury of a bedstead. The parlor chairs were ingeniously made from barrels stuffed, and covered with copper-plate. . . . The family bed occupied half the kitchen, and was separated by a wall of the gay-colored dry goods that served for upholstery." (Courtesy of Brooklyn Historical Society.)

The pioneers in northeast Hennepin County anxiously awaited statehood while the federal government cautiously balanced the number of free and slave states as the country moved closer to the Civil War. With a population of 150,037, Minnesota was finally admitted as the 32nd state on May 11, 1858. (Courtesy of Brooklyn Historical Society.)

The symbols on the state seal, which include the north woods, falls and waterways, fields being cultivated, and a Native American moving toward the setting sun, were significant for the Brooklyn pioneer's life. The words *L'Etoile du Nord*, or "Star of the North," echoed the words of French explorers and New England settlers whose descendants settled in Brooklyn. (Courtesy of Brooklyn Historical Society.)

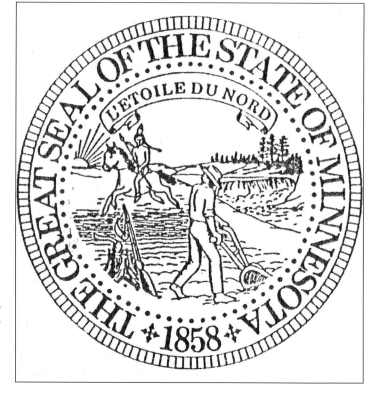

On May 11, 1858, the same day as statehood, freeholders streamed into Ezra Hanscom's home to register and vote. When the polls closed at 5:00 p.m., 128 men had voted. Elected officers included E. J. Alling, William Stinchfield, Joseph P. Plummer, Ezra Hanscom, James McKay, James Norris, L. T. B. Andrews, H. H. Smith, A. H. Benson, J. M. Durnam, W. D. Getchell, and Josiah Moore. Shown here is a map of the township by John W. Shaffer, county surveyor. (Courtesy of Brooklyn Historical Society.)

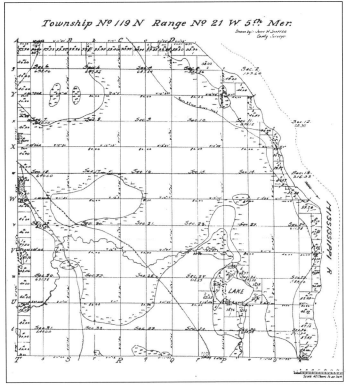

The freeholders determined hogs and sheep could not run at large; but "peaceable, orderly" cattle could roam, and horses were given free reign as long as they were not "unruly and stud" horses. Officers suggested $300 be raised for damages and settlers began building fences. Also, they voted on the name, Brooklyn Township, after a train depot in Brooklyn, Michigan. (Courtesy of Brooklyn Historical Society.)

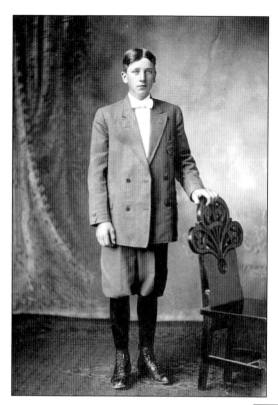

George Rochat, seen at left in 1903, was a descendant of Jules Rochat, a 34-year-old Swiss watchmaker who arrived on the *Argo* on June 28, 1866, in New York. Jules Rochat paid $1,200 for 58 acres near "Bottino preyrie," including a three-bedroom house with an attic, stable, and fences. "We can have as many cows as we want, chickens, pigs, ducks, geese, and pigeons. We go hunting whenever we want." (Photograph by Sussman Photography; courtesy of Brooklyn Historical Society.)

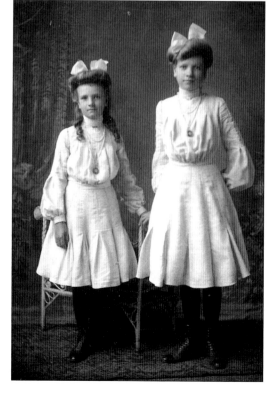

"We have a full freedom here. . . . We do not have as much concern here about living. . . . We only work ten hours per day from 6 to 12 and from 1 to 6 in the summer, and when the days are shorter, we work until the night and we don't stay up late." In addition to Ina and Eva Rochat, seen at right in 1903, other Swiss settlers included the Zimmerman, Zophi, and Blesi families. (Photograph by Hennepin Studios; courtesy of Brooklyn Historical Society.)

With conscription during the Franco-Prussian War, many Germans left Europe and immigrated to the United States. They often stopped to farm in Ohio or Indiana then completed their journey and settled in Brooklyn Township. The Setzler, Hartkopf, Schulz, Goetze, and Tessman families settled on the northwest side of Brooklyn Township. Edmund Tessman (right) married Louise Setzler in 1901 and had six children, Raymond, Irma, Alice, Lawrence, Vernon, and Lloyd. (Photograph by Nelson Photographers; courtesy of Brooklyn Historical Society.)

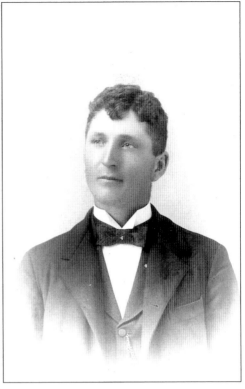

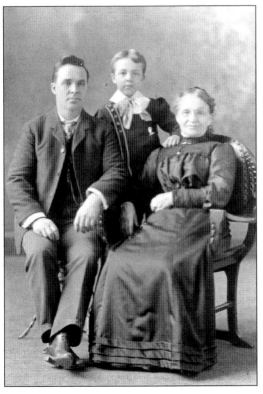

George and Mary Zahm Setzler were Germans who settled in Monroesville, Ohio. After homesteading in St. Paul, they farmed in Brooklyn Township just south of Osseo. George Setzler was a cooper and sold barrels to merchants from both St. Paul and St. Anthony. Ed Setzler was one of eight children and became a butcher in Osseo. Ed Setzler, his son, Alphonz, and his mother, Mary Zahm Setzler, appear in this photograph. (Photograph by Unser/Bellvue Photographers; courtesy of Brooklyn Historical Society.)

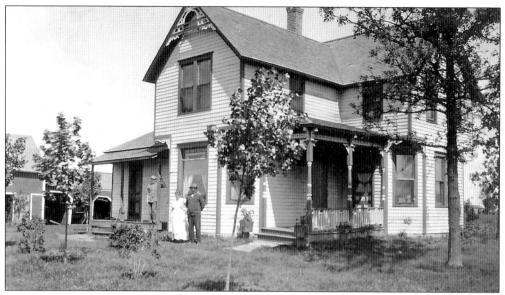

The Swedish and Norwegians settled on the southeast corner and along the east side of Brooklyn Township. Elmer Sandholm's mother and stepfather, Natalia and Alfred Larson, appear with Sandholm at a large home at Fifty-seventh Avenue and Colfax Avenue North. This home is typical of the era with gingerbread trim on the cornices, a side porch for company, and a good-size back porch for chores. (Courtesy of Brooklyn Historical Society.)

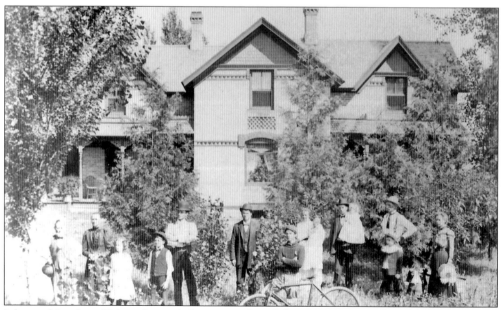

John and Ingeborg Eidem changed their name from Johnson upon arrival in the United States. By 1887, they began raising six sons and three daughters on their 100-acre farm. John Eidem Jr.'s farm was preserved by Brooklyn Park in 1979. Several times each year, guests can step back into the 1900s. A slogan of the City of Brooklyn Park maintains, "To preserve our past is to know our future." (Courtesy of Brooklyn Historical Society.)

After success as a California forty-niner, Capt. John Martin shipped $15,200 of gold east. He returned to Vermont, packed up his family, and headed for Minnesota. When he arrived, St. Anthony was starting to grow, and Minneapolis did not exist. He founded the John Martin Lumber Company and began lumbering on the Rum River. Next he invested with St. Anthony businessmen and purchased the steamboat *Fall City* in 1856. (Courtesy of Earle Brown/Brooklyn Historical Society.)

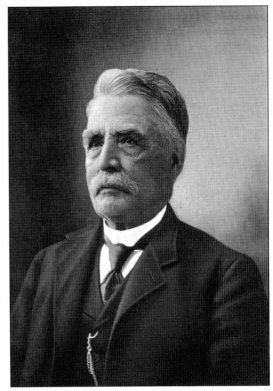

Martin served leadership roles within the First National Bank of Minneapolis, the Minneapolis and St. Louis Railway and the Soo Line Railroad, and the Northwestern Consolidated Milling Company. With interest to the north, Martin bought property in Brooklyn Township. His daughter and grandson Jean and Earle Brown moved to the farm in 1880. Brooklyn Center today offers the Earle Brown Heritage Farm as a conference and event center. (Courtesy of Earle Brown/Brooklyn Historical Society.)

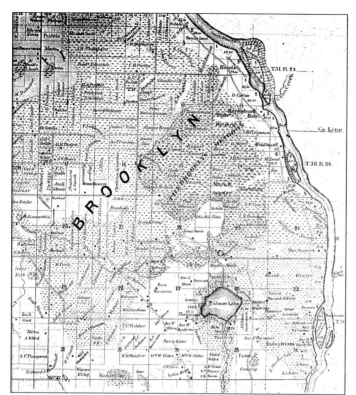

Not everyone was as successful as John Martin. J. C. Past came from Pennsylvania to manage the industrial mill built along the Mississippi River near Sixty-ninth Avenue and Willow Lane. After an explosion in 1861, the town of Industriana met a premature death. Past's youngest son, Marcus Aurelius Past, joined the 1st Minnesota Volunteer Regiment and died at Gettysburg. Pictured here is a portion of an 1873 Hennepin County map. (Courtesy of Brooklyn Historical Society.)

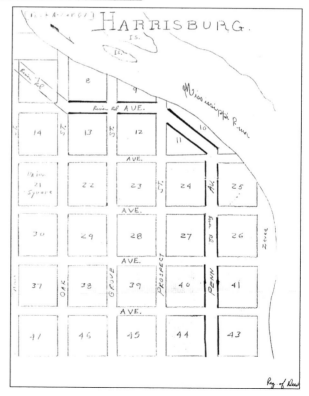

Harrisburg was plotted out with a hotel, several houses, and a couple stores. Warwick became one of the first post offices in Brooklyn Township. These towns died away like Industriana as legendary ghost towns. Other towns, such as Palestine, City of Attraction, and Farmersville, were absorbed into larger towns such as Osseo and Robbinsdale. (Courtesy of Hennepin County Registrar of Titles, Deeds, and Land Records.)

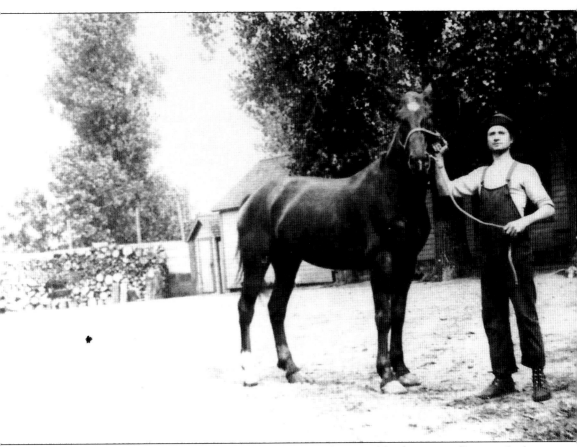

Jules Rochat described early livestock: "There are horses here not like the ones in Europe which have long hair on their legs—here they do not have any hair. . . . There are cows, heifers, and calves that never go under any shelter no matter what weather is like. They sleep in the snow. They wander around the houses to lick where waters were dumped, or they find garbage. They are seen on top of manure near the stables where there are only horses. They eat the straw or hay from the manure piles. They have long hair like bears. Horses are in stables which are only hangars made of planks where it freezes like outside but they are still protected. The good stables like in Switzerland are unknown in this country." Above, Julius Eidem exhibits champion care of his horse. (Courtesy of Eidem family/Brooklyn Historical Society.)

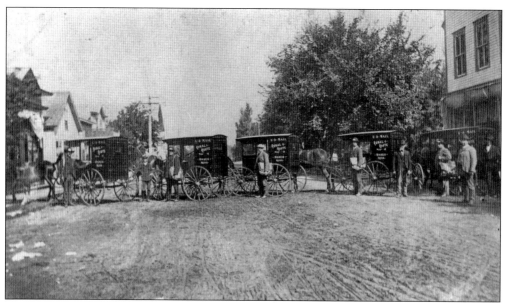

On July 15, 1855, Warren Sampson became postmaster of the Osseo service. By the 1900s, five vehicles (above) were available for service to the farmers. During service cutbacks in 1916, Gabe Zimmerman, J. A. Theerin, Fred Schreiber, and I. Dahl all received mail one day late. A. P. Mattson received notice too late to attend a relative's funeral. All these affidavit complaints were sent to Washington asking for improvements. (Courtesy of Osseo Preservation Society.)

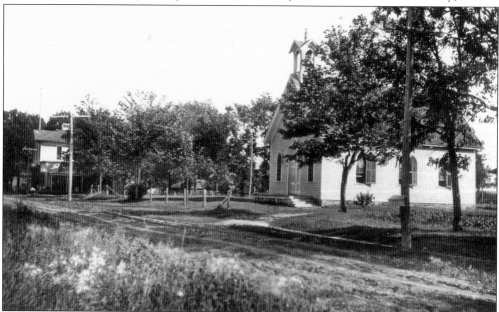

The Harrisburg Post Office under Cyrus Helliman began in 1866. When Charles Reuel Howe became postmaster in 1873, the Harrisburg office closed. By 1875, Howe's Groceries became the post office at Sixty-ninth Avenue and Osseo Road (pictured, with the Baptist church and Howe store to the far left). The post office offered triweekly mail deliveries. Brooklyn Park, the sixth-largest town in Minnesota, did not receive a post office until 1995. (Courtesy of Brooklyn Historical Society.)

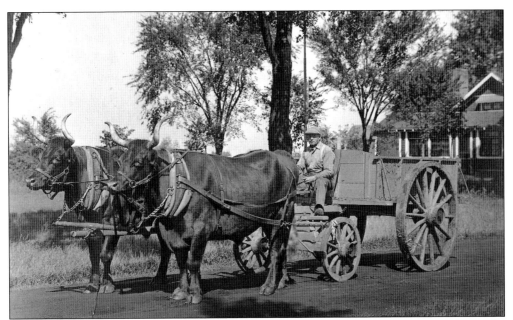

During the 1850s, furs and merchandise were carried by the Red River carts. Similar to the oxcarts above owned by Earle Brown, Red River carts were made entirely of woods and rawhide. A cart would arrive from Pembina to trade furs in St. Paul. Along East River Road and sometimes along West River Road, the squeaky wheels could be heard for miles. (Photograph by Charles J. Hibbard; courtesy of Brooklyn Historical Society.)

Levi Longfellow, one early Brooklyn settler, described the annual arrival of the oxcarts: "I remember the greatest excitement every summer was the caravans of carts from the Red River of the North. They would come down to disperse their load of furs, go into camp in St. Anthony and remain three or four weeks, while selling their furs and purchasing supplies. The journey and return required three months." (Courtesy of Brooklyn Historical Society.)

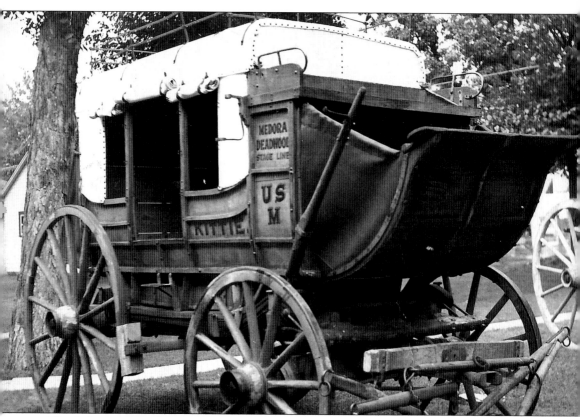

The dark green Camden-Brooklyn Township-Anoka stage with yellow trim was heavy built and long, with a roof that extended out to shield the driver. Passengers entered from the back door rather than from the side like this one from Earle Brown's collection. Four horses pulled the stagecoach along its route. Driver Bill Mahney "wore a mustache and goatee, a wide-brimmed frontier hat, and enjoyed his plug of tobacco." In the early 1900s, the stage left Camden at 4:00 p.m. and arrived in Anoka at 7:00 p.m. The route traveled the narrow, gravel West River Road past the Halfway House and Warwick in Brooklyn, through Champlin, and over the Mississippi River and Rum River bridges to Bridge Square in Anoka. The horses and stage stayed overnight in the livery barn then returned to Camden at 7:00 the next morning. (Courtesy of Brooklyn Historical Society.)

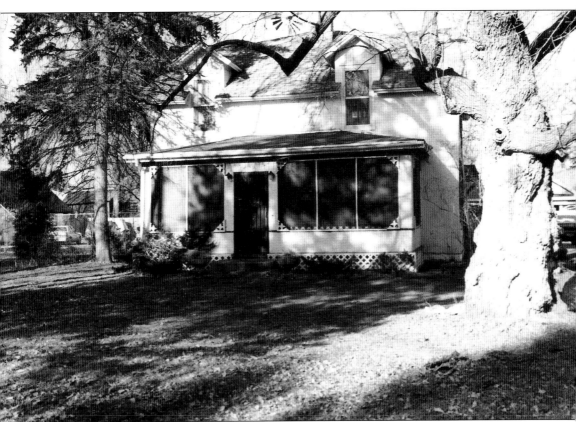

The Halfway House (above), also known as the Mattson-Rixson house, was built near Eighty-sixth Avenue and West River Road and was halfway between Anoka and downtown Minneapolis. Ike Anderson often rode the stagecoach and received free rides by helping the driver. At the Halfway House stop, he would take bits out of the horses' mouths and water down the horses. The lead horses were led to a wooden watering trough near the windmill, and buckets of water were brought to the pole team. Once refreshed, the horses and travelers got back on the road. For $1, an individual and his team received both food and lodging. The barn stabled as many as 24 horses. In later years, the family advertised "modern tourist rooms" with "inner spring mattresses." (Photograph by Jane Hallberg; courtesy of Brooklyn Historical Society.)

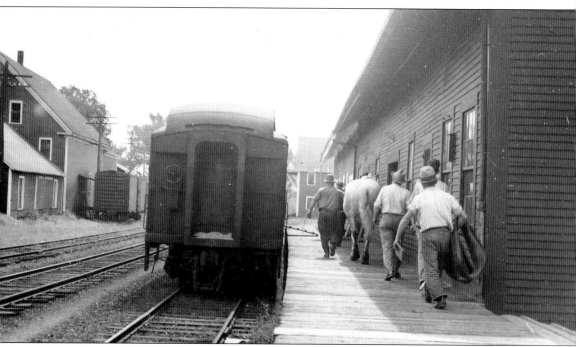

Once the St. Paul, Minneapolis and Manitoba Railway reached Osseo in 1881, farmers on the northwest side of Brooklyn Township were able to ship their crops from the Osseo depot into Canada and to the West Coast. This assured the success of the Brooklyn farms. After James J. Hill purchased the railroad, it became known as the Northern Pacific Railway. Earle Brown purchased the rights to the railroad spur at Forty-ninth Avenue between Brooklyn Center and Minneapolis. He was able to ship his produce as well as load his prize horses onto the Soo Line Railroad with trains that traveled to Chicago and to his other home in Vermont. In the late 1930s, Roy Howe secured rights and shipped potatoes and later Howe "Best Buy" Fertilizer from this convenient location. (Courtesy of Earle Brown/Brooklyn Historical Society.)

# Two

# EARLY SCHOOLS, CHURCHES, AND ACTIVITIES

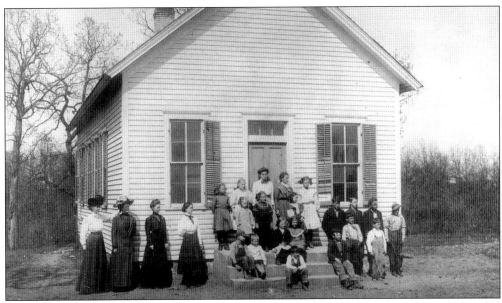

Education was important to the settlers. Separate Brooklyn Township settlements banded together and built one-room schoolhouses. In 1862, Gov. Alexander Ramsey requested that small school districts be formed. Revenue was to be levied from liquor licenses and fines for crime. Minnesota's historian and secretary to Pres. Abraham Lincoln, Edward D. Neill, wrote in 1881 that Brooklyn Township had seven one-room schoolhouses. Most were named after the closest farm or town. (Courtesy of Brooklyn Historical Society.)

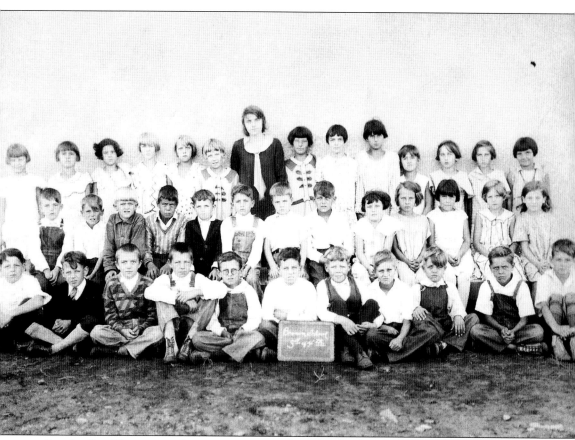

For the first 75 years, teachers were young and single like the teacher above who is standing between Eva and Evelyn Heidenreich in a 1930s Brown School photograph. Mary Harrison was the first Brooklyn teacher. "I taught the first school at Shingle Creek when I was a girl of seventeen. My school house was a claim shanty reached by a plank from the other side of the creek. The window of the school house was three little panes of glass which shoved sideways to let in the air." One day Native Americans darkened the windows. Since they carried guns and did not look friendly, the children flocked to Harrison, who suggested they sing. The Native Americans were delighted with the singing. After school, Harrison brought an atlas outside and let them view the pictures. When done, they left with a "friendly glance" back. (Courtesy of Pat Keefe Rice/Brooklyn Historical Society.)

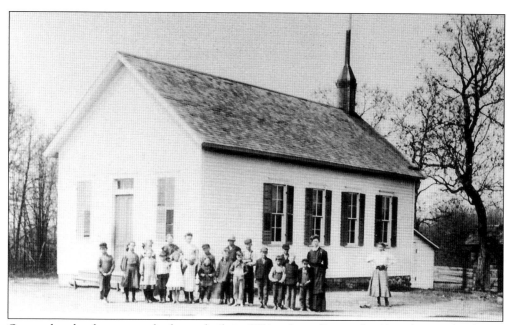

One early school was a crude shanty built in 1854 at Long Prairie for 10 students. The shanty had a board roof and two half windows. The next summer, a Reverend Partridge offered his wife as the teacher and shed as the schoolhouse in the southwest corner of Brooklyn. The shed was covered with straw and had an earthen floor and horse stalls. When Mrs. Partridge became too ill, she was replaced by Mary Smith. (Courtesy of Brooklyn Historical Society.)

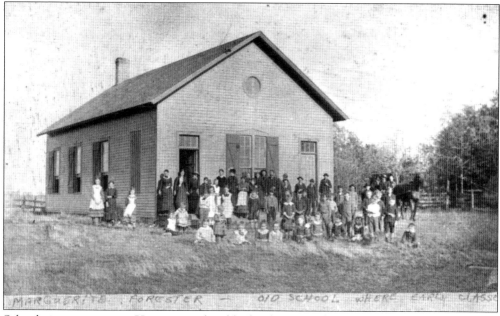

School picnics were rare. However, at the old school, seen in this 1884 photograph, the students and their younger sibling guests enjoy the special event and pose to commemorate it. Early Brooklyn Township families in the photograph include the Bohanon, Hamilton, Ham, Watson, and Munson families. (Courtesy of Brooklyn Historical Society.)

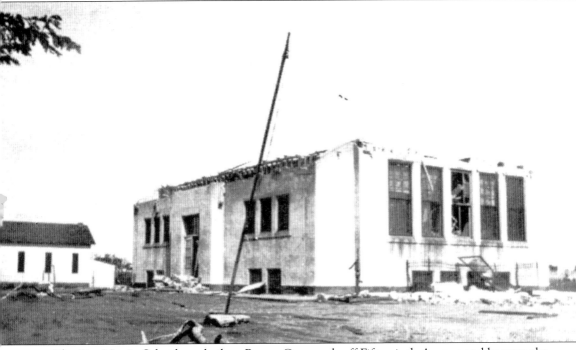

The Cap Martin School was built at Brown Crossroads off Fifty-ninth Avenue and became the first school in District No. 118, later renamed the Brooklyn Center Independent School District No. 286. Frank Smith Sr. and Adolph Boyson remembered room temperatures in the Cap Martin School as "extremely warm near the stove while at the edge of the room the drinking water bucket would have ice on top. Sometimes students would bring potatoes to school and place them on the top of the stove so they would have a hot lunch later on. Children learned with handed-down textbooks, including the McGuffey reader, and the 'glorious time at the Christmas party with apples, oranges and candy given to the children in a mosquito netting sacks.'" The building had white clapboard siding with a steeple and a bell, damaged beyond repair in the cyclone of 1929. (Courtesy of Brooklyn Historical Society.)

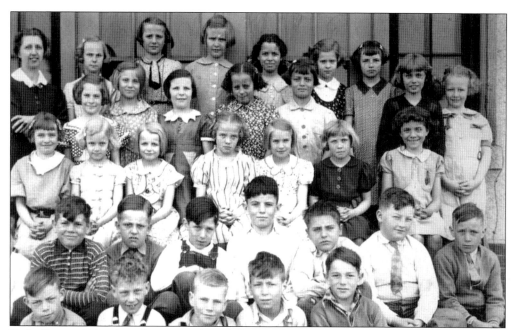

Earle Brown School students are, from left to right, (first row) Gilbert Claypatch, Eugene Polydisky, Francis Pumarlo, Lawrence Sonnenberg, and James Breuninger; (second row) Albert Mork, Donald Keefe, Eugene Blascyk, Stanley Siedlecki, John Johnston, unidentified, Clifford Jensen, and Art Swanson; (third row) Margaret Lampe, Geraldine Murphey, Patricia Wunderlich, unidentified, Arleen Peter, Beverly Lindberg, and Alice Scott; (fourth row) unidentified, Georgia Sonnenberg, Audrey Lent, Joyce Locke, Donne Doane, Joyce Tallman, and Margaret Estes; (fifth row) Doris Engstrom, Lenora Brown, Ida Mae Bittner, Virginia Edling, Caroline Gotchy, Bernice Sam Letzka, and Dorothy Dean. (Courtesy of Donna Jannich/Brooklyn Historical Society.)

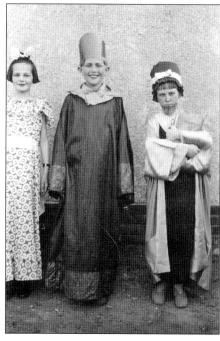

From left to right, Betty (Christofferson) Enge, Charles Gagneth, and Kathryn (Koch) Martens had roles in their school play *The Littlest Clodhopper*. Elsie E. Born was principal of Brown School in the early 1930s. Edith Bouley taught first grade, "a stout and hearty" Caroline Haertel taught second, Doris R. Engstrom taught third, Pauline C. Martoccio taught fourth, Christine Munson instructed fifth and sixth, and pretty Jean Gibbons, the sister of boxer Tommy Gibbons, taught seventh. (Courtesy of Brooklyn Historical Society.)

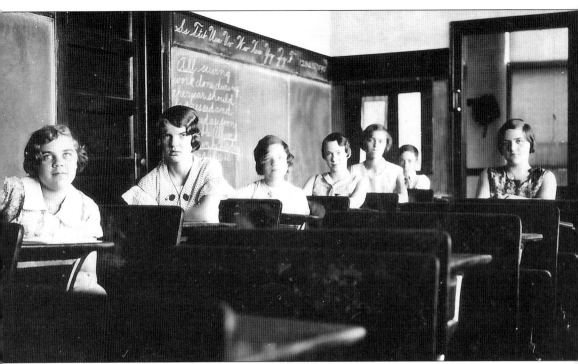

At the Earle Brown School, the desks were wrought-iron standards with the front open for books, as shown from left to right with ? Lane, ? Madigan, ? Bohanon, Helen Norris, Lili Pearson, Bernard Keefe, and Mildred Holmes. Upper grades had a groove for pencils and pens and a hole for holding the ink bottle. Lunches were brought from home in buckets, lunch boxes, or wrapped in newspaper or bags. By the late 1930s, Mothers Club, the Parent-Teacher Association, and work programs made available a hot bowl of soup, milk for 1¢, and chocolate milk for 3¢. Ice-cream bars were also available for 5¢. Individuals who found the word *free* on the stick got their next one free. The Earle Brown School has gone through several teardowns and renovations, from a one-room to a two-story to a modern design. (Photograph by Van Vranken of Winona; courtesy of Brooklyn Historical Society.)

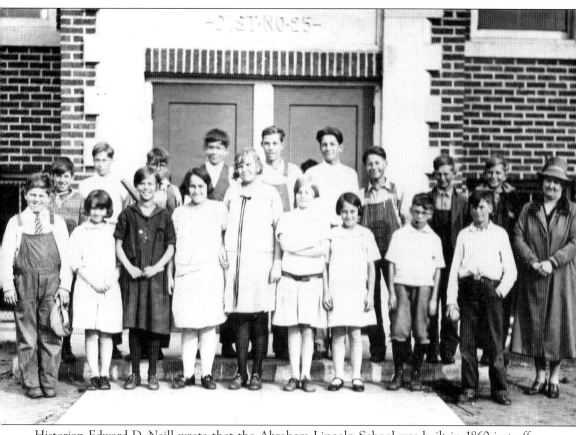

Historian Edward D. Neill wrote that the Abraham Lincoln School was built in 1860 just off Sixty-second Avenue and West Broadway. When the school burned in 1895, its replacement was called Coulter School then renamed Abraham Lincoln School in 1926. Today that school is in Robbinsdale Independent School District No. 287. The first mayor of the village of Brooklyn Park, Baldwin "Baldy" Hartkopf, attended Coulter School, which was located just south of Smith School. Like most early schoolboys, he remembers long walks to school with his brother. Sometimes they followed behind a wagonload of hay to protect themselves from the icy winds. Also in District No. 287 was Twin Lake Elementary School (above) at 4938 Osseo Road. The school was originally in District No. 25. It continued in use as a kindergarten into the 1950s and is known today as the Twin Lakes Alano. (Courtesy of Brooklyn Historical Society.)

John Dunning donated land in 1860 for Dunning School. Cora Lane Hunt attended and said her instructor, a Mr. Lee, "ruled by the rod." Older boys "were punished with the pointer or French twist." Girls sat in the corner wearing a dunce cap. Her father hitched up the sleigh and picked up others on cold days. Girls sat on one side of the room with boys on the other side. (Courtesy of Brooklyn Historical Society.)

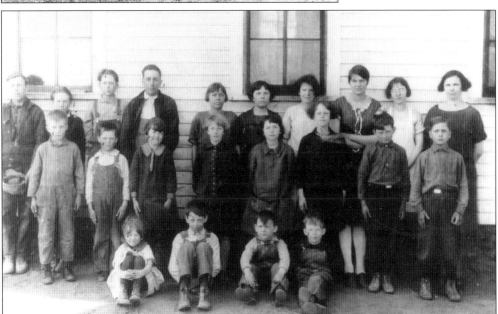

Dunning School was built in 1860 at 109th Avenue North and West River Road. During the 1920s, Florence Street taught at Dunning School. Her first day went as anticipated with spitballs flying about the room and off the walls. The next day, Street returned in control. Her ball-spitting students were forced to stay after school, make hundreds of spitballs from newspaper, and line them up on the teacher's desk. (Courtesy of Brooklyn Historical Society.)

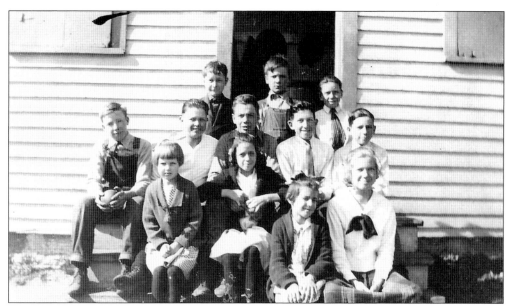

Dunning School began as District No. 99 and came under Anoka-Hennepin Independent School District No. 11. Edward D. Neill cited that the Cotton School built near the Delavan Cotton Farm in 1873 was destroyed by fire. Riverview School was built nearby and is still in use today. Typical students pose on the back steps of the school. (Courtesy of Brooklyn Historical Society.)

When the Bensons arrived from Maine, they homesteaded in Brooklyn Township. In 1872, they built a white wooden, one-room schoolhouse at Seventy-third Avenue and West River Road. Around 1917, the school was replaced by a two-story brick building. Ole Anderson, the school's janitor, purchased the discarded school. When he died, it passed to Gerdun Palmquist. (Courtesy of Brooklyn Historical Society.)

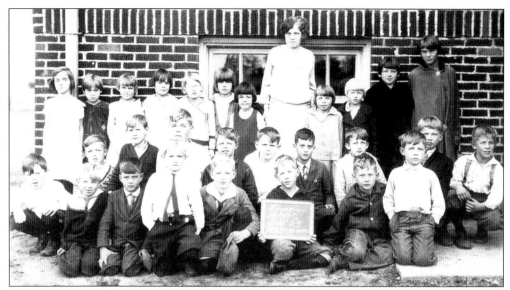

Anton (Tony) Renko remembered 1929 classmates. From left to right are (first row) Philip Bergstrom, Frank Renko, Harvey Anderson, Alfred Fisher, Clyde Olson, Ronald Clark, and unidentified; (second row) Frank Mezerka, Donald Gerber, Edward Yacklich, George Gerber, Ervin Peterson, Ted Nordquist, Tony Renko, Estel Holmberg, Virgil McNab, and Jack Olson; (third row) Shirley Haskell, unidentified, Nellie Sienko, Harriet Crooker, Stella Holmberg, unidentified, Joan McNab, ? Johnson, Mary Mazerka, Lenore Peterson, Nora Norlander, and ? Cotton. (Courtesy of Mavis Huddle/Brooklyn Historical Society.)

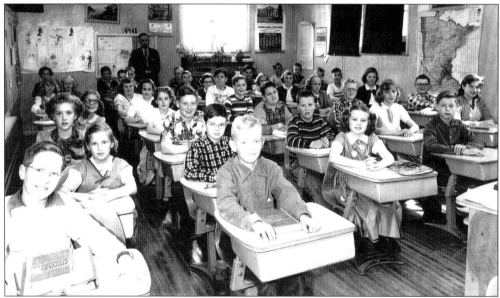

Garrison Keillor of Lake Wobegon fame, pictured in the second row from the left and in the second desk, attended Benson School. In 1957, students were reassigned to Riverview School. Eventually these same students attended school in Anoka. One classmate said they were always like "outsiders" and treated as though they were "country hicks." The City of Brooklyn Center used the brick Benson School as a city hall until it was torn down in 1976. (Courtesy of Brooklyn Historical Society.)

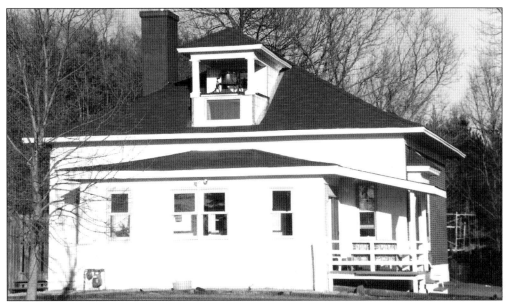

The fourth district in the area occupied by Brooklyn Township was Osseo Independent School District No. 279 with the Brooklyn Center, Berg, Zophi, Schreiber (above), and Smith Schools. Today the Zophi and Schreiber Schools are homes. The Berg School was torn down in the 1970s, and fire took the Brooklyn Center and Smith Schools that were being used as Brooklyn Center's village hall and Brooklyn Park's police station, respectively. (Courtesy of Brooklyn Historical Society.)

The Brooklyn Center or Howe School was a two-room schoolhouse on Seventy-first Avenue and Osseo Road. The first to fourth grades were in one room and fifth to eighth were in another. Keith Caswell thought "Mrs. Brown, Thelma Howe, and Jeanette Fair were excellent teachers." Fair, listed as a 1908–1909 graduate in the Berg School souvenir booklet (above), later became principal of the Adair School for the Robbinsdale School District. (Courtesy of Brooklyn Historical Society.)

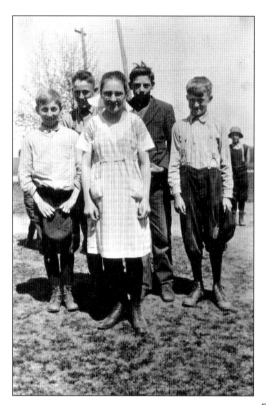

The Smith School in Skunk Hollow was originally at Eighty-ninth Avenue and West Broadway. As a six-year-old, Baldwin "Baldy" Hartkopf attended when Mary Savage was the teacher. Other students were Ida and Eddie Brown; Karl, Flora, and Alma Hartkopf; William and Karl Schmidt; Florabella and Georgia "Snowball" Smith; Augusta Willie and Ellen Neddersen; and Clara and Agnes Tessman. Alice Tessman, pictured here front and center, attended several years later. (Courtesy of Brooklyn Historical Society.)

John Fair, Ole T. Berge, and W. H. Meinke met on July 18, 1908, to determine annual expenses. They approved $360 for the teacher's salary, $21.50 for repairs and improving grounds, $5 for library books, $9.88 for textbooks, and $33.48 for miscellaneous items, totaling $429.86. Later records indicated $31.60 was paid for wood. Isebelle Miller worked the year of 1908 for eight months at $45 per month. (Courtesy of Brooklyn Historical Society.)

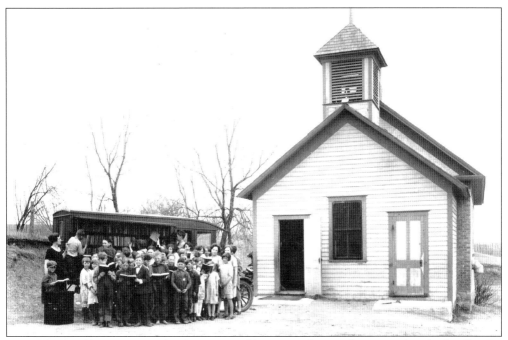

Since the small one-room schools were unable to purchase a large supply of schoolbooks, Hennepin County provided a book wagon. By visiting the various schools, it gave children access to additional reading materials. When the large school districts were developed in the 1950s, library rooms were added to each school, and librarians were available to guide children with their research and book selections. (Courtesy of Brooklyn Historical Society.)

Ted and Dennis Klohs take advantage of the bookmobile that visited the Ninety-first Avenue and Irving Avenue North neighborhood in 1953. The old Brooklyn Center Library was built in 1965 off Fifty-sixth Avenue and Osseo Road and was replaced by the Brookdale-Hennepin Library in 1981 at Sixty-first Avenue and Shingle Creek Parkway. The Brooklyn Park Library opened on April 26, 1976, at Eighty-sixth and Zane Avenues. (Courtesy of Marian Klohs/ Brooklyn Historical Society.)

<div style="border: 2px solid black; padding: 10px;">

# "BACK TO THE FARM"

### A Play In Three Acts

──────── To Be Presented At ────────

## School House, District 118

### on

## Saturday Evening, May 5th, 1917

──────────────────────────────────

**Tickets 25 Cents**       **Curtain raised at 8:15**

</div>

The agricultural extension of the university farm in St. Paul published a play, *Back to the Farm*, in 1914. Playwright Merline H. Shumway was from the area. In addition, the Merrill farm, events within the play, and the characters echoed a bit of Brooklyn charm. With the fast-changing world, the play was a call to grab everyone's attention and bring them "back to the farm" while accepting modern-day farming methods. (Courtesy of Brooklyn Historical Society.)

### Program

### "BACK TO THE FARM"

#### A PLAY IN THREE ACTS

BY

MERLINE H. SHUMWAY

TO BE PRESENTED AT

### NEW SCHOOL HOUSE

DISTRICT 118

SATURDAY, MAY 5th, 1917

The play was performed again on September 14, 1921, at the West River Road Community House. The 1921 program read, "This play is one of real life based on actual facts. As the play progresses you will see and hear things that make you think and wonder whether you are one of those who are still following the old school. This play is actual; see the circumstances of life swing Merton, the farmer boy; and watch the effect of mother love as things grow brighter." (Courtesy of Brooklyn Historical Society.)

44

The play was performed at the new schoolhouse of District No. 118 on Saturday, May 5, 1917. Mae Smith directed it with actors Mary Nelson, Esther Glyer, Sigurd Kolstad, Vivian Harthen, Mae Larson, Lillian Glyer, Ike Anderson, Glenn Wilcox, and Robert Brown. Kneeling (below) is Albert Garrett. (Courtesy of Brooklyn Historical Society.)

## CAST OF CHARACTERS

| | |
|---|---|
| Charles Merill, a farmer of the old school | Sigurd Kolstad |
| Merton Merill, his son | Albert Garrett |
| Mrs. Merill, the farmers thrifty wife | Vivian Harthen |
| Rose Meade, the school ma'am | Mary Nelson |
| Gus Anderson, the hired man | Ike Anderson |
| Reuben Allen, a neighbor | Lillian Glyer |
| Mr. Ashley, lawyer and real estate agent | Robert Brown |
| Robert Powell, a senior in law | Glenn Wilcox |
| Margerie Langdon, a promising society debutante | Mae Larson |
| Hulda, the maid | Esther Glyer |

Mrs. Mae Smith, Director

ACT I

The Merill farm. Mid-autumn, 1906. Morning

ACT II

The University of Minn. Five years later. At the fraternity ball.

ACT III

Merton's Study at the Merill farm. Two years later. Morning.

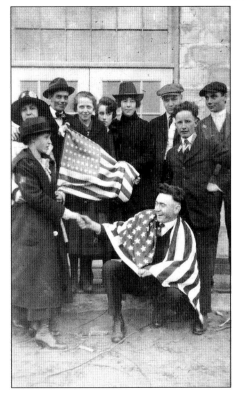

The hired hand, Gus Anderson, was played by Ike Anderson. The program described his character as "a large-boned, awkward man of thirty. He was of decided Scandinavian type with a shock of yellow hair and had a broad Scandinavian accent." (Courtesy of Brooklyn Historical Society.)

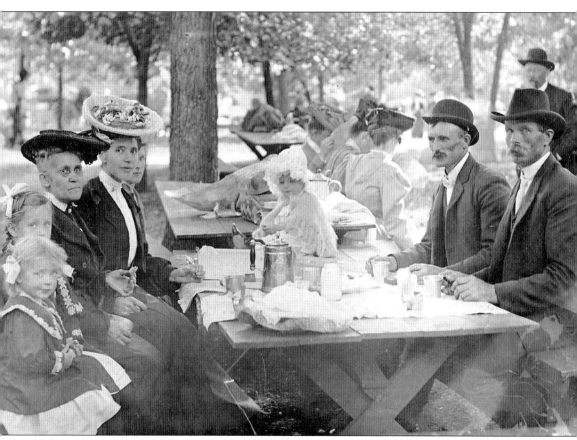

Picnics were the typical way that Brooklyn families celebrated special occasions. George and Mary Buchholtz were no exception as they celebrated their 50th wedding anniversary (above) on Sunday, October 8, 1905. Another festive occasion was July 4, 1901, the Getchell family's 50th anniversary of coming to Minnesota. Mary A. Getchell recalled her early Brooklyn home of February 1853: "We arrived about 4 o'clock in the afternoon. Father had the oven full of baked potatoes, and even now in imagination I can smell these same potatoes." The Hiriam Smith family celebrated when cranberry bogs were found in the marshlands. Mary (Smith) Pribble wrote, "Much picnicking and picking followed. My parents secured seven bushel." Celebrations such as these carried the early settlers through the grasshopper infestation, the panic of 1857, and the Civil War. Their descendants equally celebrated the good times. (Courtesy of Brooklyn Historical Society.)

John Eidem Jr. was John and Ingaborg Eidem's first child. On April 29, 1892, he married the neighbor girl Electra "Lectty" Cotton. Two years later, they purchased the Julia Bragdon farm on 101st Avenue North off Noble Avenue and moved into the house that is today called the Brooklyn Park Historical Farm run by the City of Brooklyn Park Department of Recreation and Parks on 101st Avenue North. (Courtesy of Brooklyn Historical Society.)

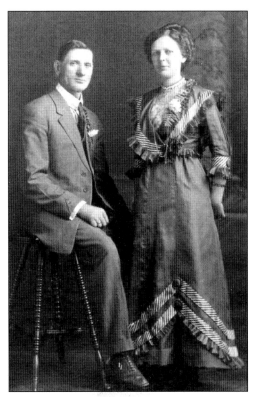

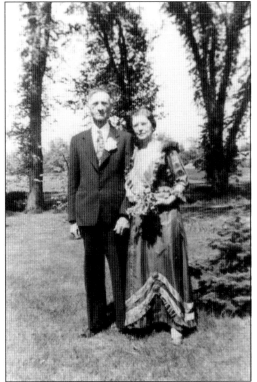

Not everyone can wear their wedding gown on their 50th wedding anniversary. Electra Cotton Eidem was one of those versatile women who not only fit in her gown but danced every dance at the Riverlyn Restaurant where they celebrated. She raised two sons. She also was a teacher, drove a car, played the piano, loved flowers, was skilled at needlework, and baked excellent apple coffee cake and chicken potpies. (Courtesy of Brooklyn Historical Society.)

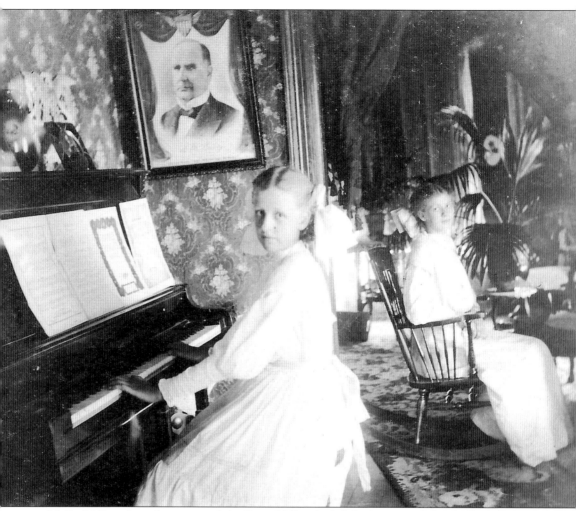

Molly Miller plays the piano while Dora Miller (right) looks on at John Miller's home at Seventy-second Avenue and Logan Avenue. Families enjoyed playing the piano or singing together at gatherings on Saturdays or Sundays. Baldwin "Baldy" Hartkopf remembered the Goetze, Neddersen, Hartkopf, and Bill Schmidt get-togethers. The men played whist while the mothers chatted and handed out popcorn and chocolate cake. The children took over a bedroom or the hallway for their games. The Roy Howe family celebrated Sundays at Grandma and Grandpa Rudolph and Anna McCausland Hartkopf's house. The men played whist, the women yakked, and the children danced to Whoopee John music. A 1915 newspaper read, "The young people of Long Prairie had a sleigh ride party Saturday evening, but owing to the cold weather the ride was short. They went to the church parlors where they played games and a dainty lunch was served." (Courtesy of Brooklyn Historical Society.)

Churches were especially important as gathering places for early settlers and the farming community. The first Catholic church in Hennepin County west of the Mississippi River was in Bottineau Prairie. In 1855, Fr. George Keller celebrated holy mass at Pierre Bottineau's house. Soon after, the 30-by-50-foot Church of St. Louis was constructed. In 1864, the 32-by-54-foot St. Vincent de Paul Church replaced it in Osseo on Central Avenue on land donated by Louis Pierre Gervais. Adults and children walked miles barefoot to attend church and put their shoes on before entering the church. A bell was purchased in 1865 and a steeple in 1890 (right). When a new church was built in 1989, the Steeple Pointe Senior Apartments received the original steeple. Everyone believed it protected Osseo from tornadoes that besieged neighboring towns. (Courtesy of Anoka County Historical Society.)

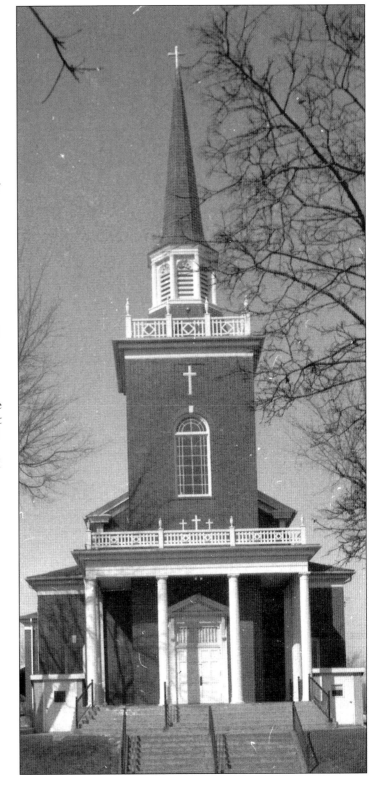

The Methodists built their first church in 1866 with J. B. Mills as the first pastor. Two years later, the Central Baptist Church was built at a cost of $2,200. On the east side, the Free Will Baptist Church (pictured) was built and later became known as the Bragdon Church because of the money left by Eben Bragdon, a soldier who died during the Civil War. (Courtesy of Brooklyn Historical Society.)

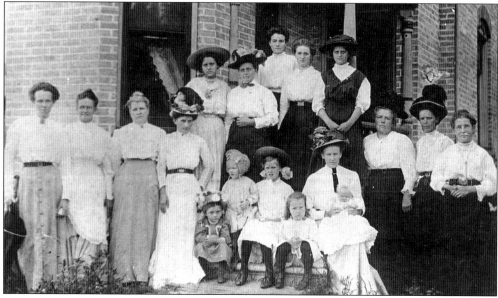

The Bragdon Ladies Aid Society from Bragdon Church's Long Prairie area met at the Dunning house around 1909. From left to right are (first row) Ida Reynolds, Margaret Dolby, Isabel Dunning, Mamie Hilton, Irene Hilton, Blanche Reynolds, Mabel Reynolds, Lois Dunning, Ella Porter with her baby, Howard Porter, Anne Gow, Lectty Eidem, and Emma Pomeroy; (second row) three unidentified women, Ethel Blake, and Hazel Blake. Today over 39 churches are thriving within Brooklyn Park and Brooklyn Center. (Courtesy of Anoka County Historical Society.)

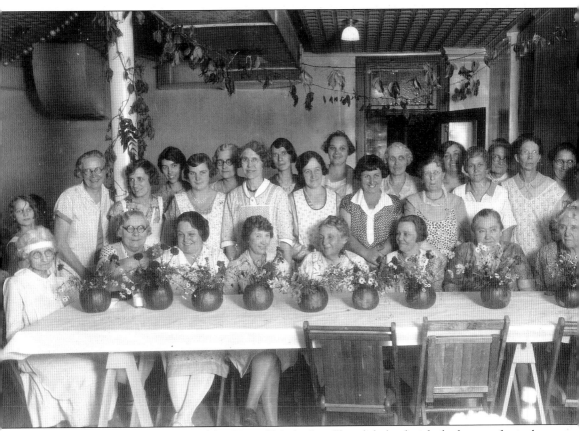

The Ladies Aid Society of Brooklyn United Methodist Church helped with the harvest festival. From left to right are (first row) Kit Drake, Emma Howe, Marie Hamilton, Ann Hamilton, Minette Bohanon, Blanche Lawrence, Clara Norris, and Emma Hanscom; (second row) Mary Lou Gadow, Olive Hamilton, Doris Gadow, Myrtle Copeland, Mary Buchholtz, Grace Mattson, Laura Doten, Nettie Prunty, Delia Brunsell, Frieda Babcock, and Isabelle Johnson; (third row) unidentified, Lizzie Holmes, Ann Purham, Mae Lennartson, Junie Hartin, Edna Soltau, Rachael Johnston, and Albra Hubbard. The Harvest Home Festival celebration on September 18 and 19, 1931, included a judging exhibition, a ball game, a shotgun tournament, a chicken pie supper, a horseshoe tournament, a baby clinic, a race for boys, horse and automobile races, a watermelon-eating contest, a ladies nail-driving contest, a ladies shoe-kicking contest, prettiest hair contest, couple married the longest, a tug-of-war, and a number of other events. (Courtesy of Brooklyn United Methodist Church/Brooklyn Historical Society.)

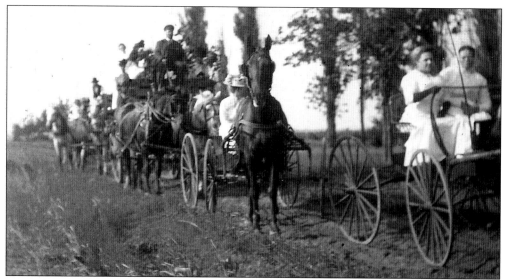

Dressed in their Sunday best, the Salem Ladies Aid Society hitched horses to their buggies for a day away from housework, and over the fields they went. They met in the early 1900s near Seventy-second Avenue and Logan Avenue North. With the everyday drudgery of washing, hanging clothes out to dry, cooking, canning, mending, sewing, and cleaning, these women looked forward to socializing while doing something extra special for the community. (Courtesy of Helen Miller/Brooklyn Historical Society.)

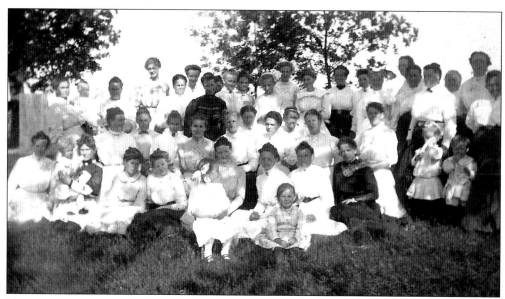

Various projects that the women completed at the ladies aid societies during World War I included donations to the camp library fund to purchase books for the various cantonments and army posts, the bat and ball fund to give the "Sammies somewhere in France a chance to play the great national game," and tobacco for "our boys in the trenches." (Courtesy of Helen Miller/ Brooklyn Historical Society.)

Mound Cemetery (right) was established about 1860 and run by a board known as the Mound Cemetery Association. Lots were sold to all applicants. It was named for a nearby Native American mound that was two rods in diameter at the base, 10 feet high, and circular in form. The mound contained bones, pottery, arrowheads, and tomahawks. (Courtesy of Brooklyn Historical Society.)

The Church of St. Louis started a cemetery on the north side of Osseo. Soon it was renamed the St. Vincent de Paul Cemetery (left). South of Osseo, the Brooklyn-Crystal Cemetery was organized in 1863. The first burials took place in 1867 with the five Getchell children. Alvah Getchell, killed at the battle of Acton at age 19, was one of those buried. (Courtesy of Brooklyn Historical Society.)

When Glen Sonneberg was interviewed about funerals, he remembered close relatives or neighbors built the casket and families held reviewals in the home. Older family members bathed and prepared the body by closing openings with a little moss. When infants died, "they would be lying right on top of the big dining room table and have love addresses and things on them and then they would lay flowers around them." (Courtesy of Brooklyn Historical Society.)

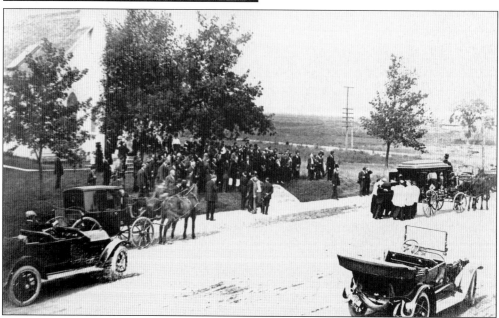

Some individuals had traditional funeral services. A huge requiem mass in 1914 celebrated Fr. Francis Savey's life at the St. Vincent de Paul Church in Osseo (pictured). Sprays of flowers were sent by close friends and relatives to decorate the casket. Other than the service said in Latin and the horse-drawn carriage that carried the casket, formal funerals 100 years ago were much like today's funerals. (Courtesy of Brooklyn Historical Society.)

# *Three*

# EARNING A LIVING

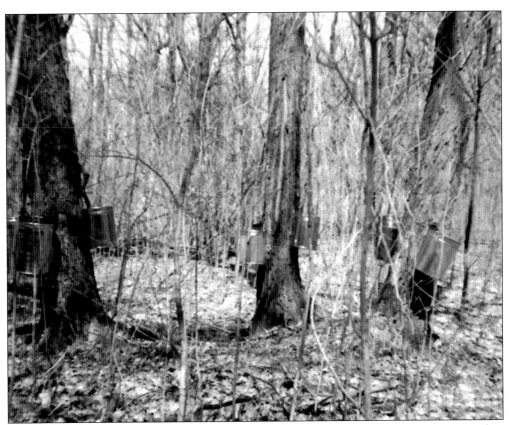

While farmers worked their fields, housewives prepared food. To preserve sweet corn, they partially cooked the corn, cut it from the cob, spread it under the sun to dry, and stored it in flour sacks in a dry upstairs room for the winter. Other early crops included wheat, oats, barley, and hay. Long a spring ritual for both New Englanders and Native Americans, maple sugar was collected to sweeten foods. (Courtesy of Rose Sandholm/Brooklyn Historical Society.)

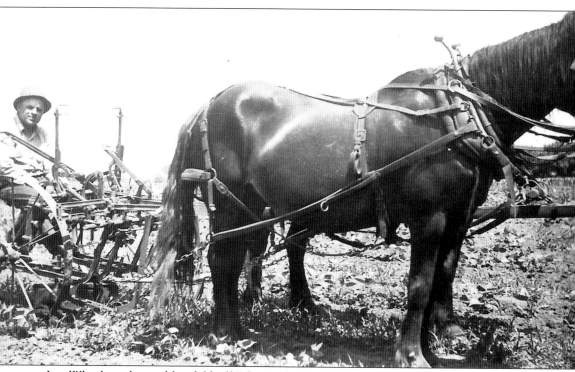

Jess Wheeler cultivated his field off Fifty-ninth Avenue and Beard Avenue in the 1930s. Jules Rochat wrote earlier, "Here one man can cultivate ten times more than in Europe. The ground is sandy and easy to cultivate. We can plough with one horse. One ploughs one time, plants, harrows . . . I should have come 5 years ago, but it is better late than never. America offers more opportunities than back home. . . . This summer I earned, for the first three weeks, 12.50 francs per day and after that 10 per day, and now 6 f. per day. The food is cheaper here than in Switzerland except for milk which costs 80 cents per jar. . . . I will have my own milk shortly without having to buy it. There are good, beautiful cows and good horses for trading and for racing." (Courtesy of Virginia Bistodeau/Brooklyn Historical Society.)

The Brooklyn prairies and marshlands yielded abundant wild hay for local use and the nearby Minneapolis market. In the 1870s, Ole Halverson, a settler from Norway, dealt exclusively with hay and sold up to 200 loads a year in Minneapolis. Often the women took straw and wove hats for their children and to sell in town. Above, Edmund Tessman stacks hay in 1928 at 6716 Eighty-fifth Avenue North. (Courtesy of Alice P. Tessman/Brooklyn Historical Society.)

Jules Rochat wrote his friends, "Here we toss the hay whenever we want. Artificial hay is tossed in July, and prairie hay is tossed in August and September. In the prairies we put the hay in big bundles when it is dry, and we load them in the winter when it is freezing so the horses can cross the swamps without sinking. The system for everything here is very different." (Courtesy of Brooklyn Historical Society.)

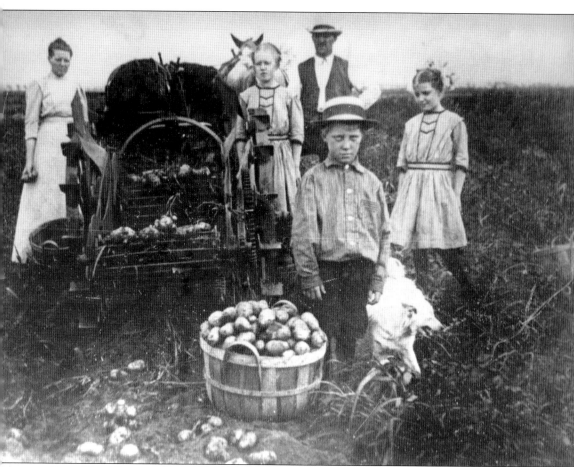

Boys, like Albert Rydeen (above) in the straw hat, helped in the fields or hired out. Frank O'Brien described haying as follows: "The sun came up betimes and smiled merrily over the broad expanse of nearly forty acres of meadow, whose grasses waved in a manner not unlike the rhythmic movements of a partially tranquil sea. . . . Almost immediately the labored and methodical 'swish-swish' of the scythes could be heard, and soon a swath was cut, followed by others in rapid succession, while I, the boy, was actively engaged in spreading the new-mown hay, that the drying winds and sunshine might cure it sufficiently to be cocked up ready for the stackers, or else loaded on the hay-rack and hauled to the barn. . . . The surplus hay . . . was disposed of in the city at the fabulous price of from eight to ten dollars a ton." (Courtesy of Rydeen family/Brooklyn Historical Society.)

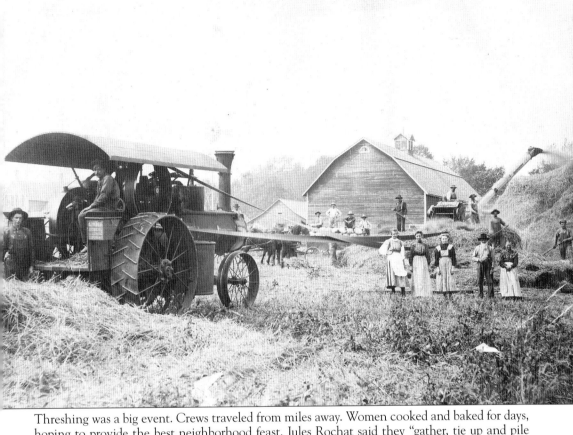

Threshing was a big event. Crews traveled from miles away. Women cooked and baked for days, hoping to provide the best neighborhood feast. Jules Rochat said they "gather, tie up and pile up the bundles. One harvests five to six acres per day; afterwards, one gathers the seeds to put them in a pile or to thresh them. We use the threshing machine and eight to ten horses, and seven to eight men." Once done by hand, the harvesting process became easier with the threshing machine in separating the grain from the stalks and husks. In the early 1900s, the local threshing contractor was Pete Newmann. The crew came in the morning to find anywhere from 3 to 10 huge stacks of grain. For those farms with less stacks, they threshed all morning and moved on to a neighbor's stacks. (Courtesy of Leo Koch family/Brooklyn Historical Society.)

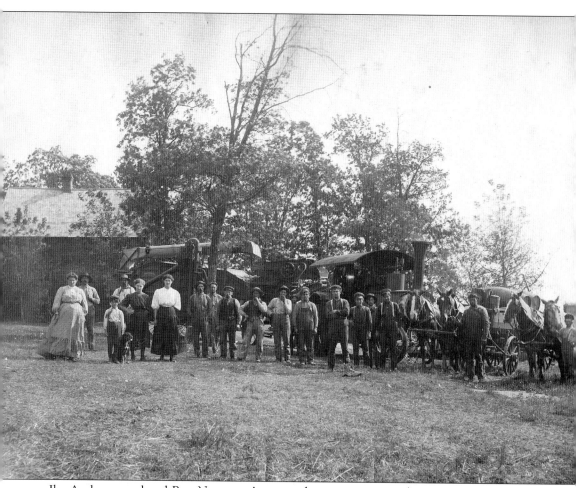

Ike Anderson replaced Pete Newmann's son as the engineer, or tanker, to monitor the steam and water gauges controlling the water supply to the steam engine. Water from the engine was pumped out of a water tank wagon. The steam engine stayed 150 feet away from the threshing machine, or separator, to avoid having the grain catch fire. A belt connected the steam engine and threshing machine. A sacker filled huge sacks as the grain flew out from the thresher. The noisy threshing machine used at the Eidem farm had the smokestack in the rear for the firebox and the steam exhaust in front. The spike pitcher tossed bundles into the machine. The fireman stood on the back platform and threw in the fuel, coal, wood, or straw to warm the water in the boiler. (Courtesy of Leo Koch family/Brooklyn Historical Society.)

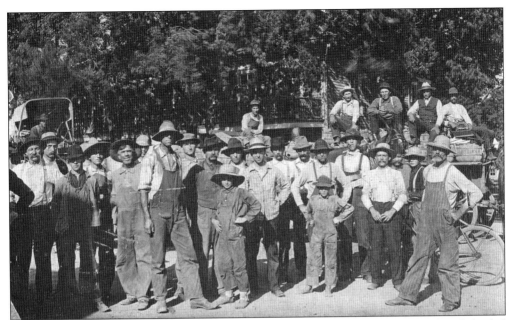

Brooklyn farmers began harvesting potatoes in early July. Lines of wagons filled with bushel baskets full of potatoes jammed the gravel road to Osseo. Here the potatoes were weighed, sold to the buyers, and shipped out on railcars. As many as 100 carloads of potatoes left Osseo during peak productivity in 1915, making Brooklyn Township one of the largest producers of potatoes in the United States. (Courtesy of Vera Schreiber/Brooklyn Historical Society.)

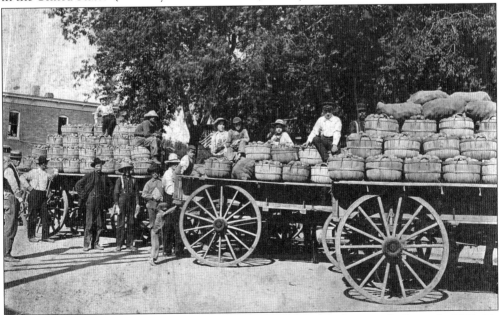

C. W. Hamilton was a typical potato farmer like those in the photograph above. In 1912, his 50-acre field gave 250 bushels of early Ohio potatoes a day. He began digging his crop on July 2 at $1.50 per bushel. During the peak of the crop, he had four horses hauling two loads a day to Osseo. A 10-year-old boy, Joseph Holmes, drove the team through the fields. (Courtesy of Vera Schreiber/Brooklyn Historical Society.)

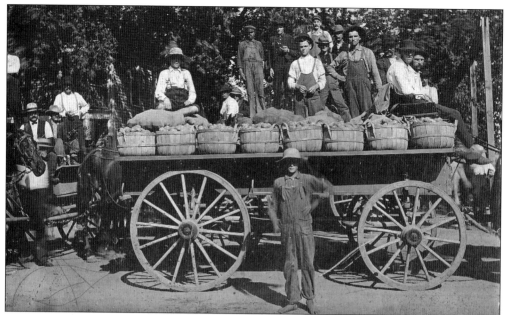

George Warner weighed an average of 87 truckloads daily, and the potato farmers and buyers expected to ship 8 million to 14 million more bushels in 1912 than the previous year when they shipped 26 million bushes. In order to ship that many potatoes, 91,900 cars were needed. If these cars were lined up, the train would be 700 miles long and reach all the way to Detroit. (Courtesy of Vera Schreiber/Brooklyn Historical Society.)

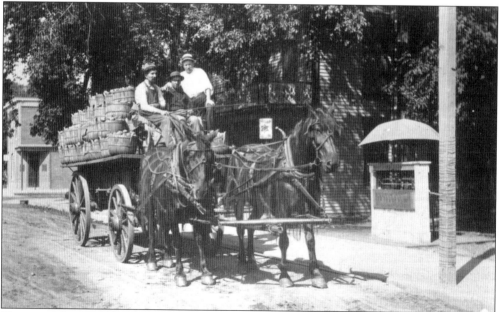

Here are Albert Tessman (left) and Aaron Tessman (center) with their load in Osseo. To the southeast, Brooklyn Center's potato and onion farmers brought their produce to the railroad tracks between Brooklyn Center and Minneapolis. Everett Howe was a buyer and a broker who shipped boxcars to Chicago. Later his sons Frank and Roy Howe were also brokers and shipped produce from the same spot. (Courtesy of Alice Tessman/Brooklyn Historical Society.)

Early farmers dug potatoes up with pitchforks. Edmund Tessman had a potato-grower's skill and could "flick the fork deftly with his wrist, popping the potatoes to the surface." Once the potatoes were unearthed, hired hands picked them up and filled bushel baskets. By 1920, the Edmund Tessman family purchased the single-row mechanical digger run by gasoline and a Cushman engine and pulled by two horses. Raymond Tessman (right) is shown as operator. (Courtesy of Alice P. Tessman/ Brooklyn Historical Society.)

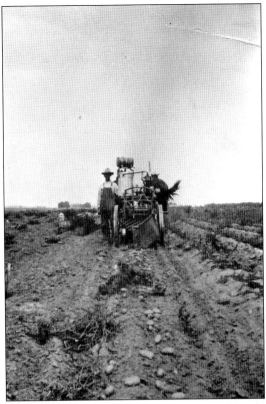

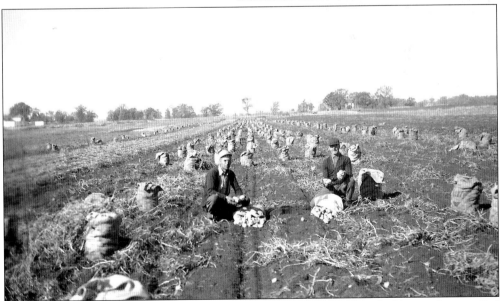

Wagons were replaced by trucks. The single-row digger was replaced by a double-row digger pulled by four horses. The Dahlman harvester, developed by Peter Dahlman of Grandy and partially financed by Aaron Tessman, was introduced in the late 1940s to make harvesting easier. Further advances continued with the four-row digger. Above, the Bernard Keefe family finalizes the bagging operation in the early 1950s. (Courtesy of Pat Keefe Rice/Brooklyn Historical Society.)

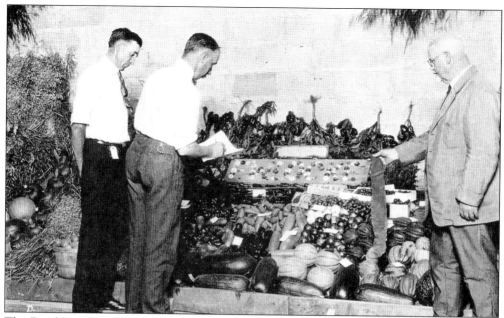

The Brooklyn United Methodist Church annual harvest festival featured produce judging as seen by the inspection of Frank Locke's top vegetables. Children also brought their favorite barnyard pets for judging. And, of course, farmers brought their produce to the Hennepin and Anoka County Fairs as well as to the Minnesota State Fair. (Courtesy of Brooklyn United Methodist Church/Brooklyn Historical Society.)

Frank Dunning took several trophies home from the Minnesota State Fair, as champion potato grower of Minnesota. His potatoes took first prize for early Ohio stock and the sweepstakes prize over all potatoes in all classes. He also took first for watermelons, pie pumpkins, and citron. His muskmelons took second prize, and his popcorn and Hubbard squash took third and fourth prizes, which showed excellent cultivation and thorough farming. (Courtesy of Anoka County Historical Society.)

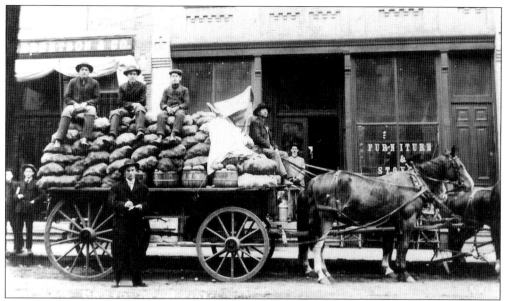

Hans Eidem (above) delivered potatoes to A. E. Coulter for C. F. Henry in Anoka off Second Street. Electricity and trucks brought advances to Brooklyn. Edmund Tessman ran a battery-operated generator and electrified his farmhouse in 1920. Northern States Power Company ran a "high line" or telephone poles in the early 1930s. Potatoes could now be washed locally. Farmers unloaded, washed, graded, weighed, packaged, and stored potatoes on their farms. (Courtesy of Eidem family/Brooklyn Historical Society.)

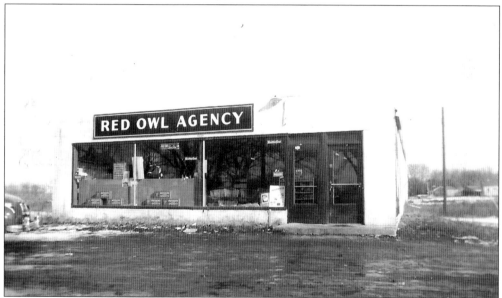

Farmers hauled produce locally. Tessman delivered to Red Owl grocery stores (above), owned by Cliff and Gen Lane off Sixty-ninth Avenue and Osseo Road. His cousins Raymond and Alice Tessman sold to Applebaum's. Wilbur Goetze sold to chain stores throughout the Midwest, the South, and Canada. He claimed, "The vast majority of potato chips sold in the Minneapolis area from mid-July to October [were] from potatoes grown in this area." (Courtesy of Brooklyn Historical Society.)

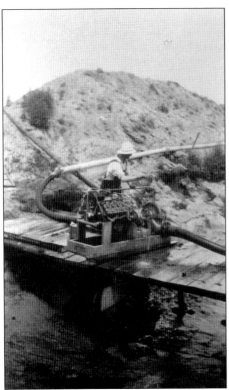

With the 1930s drought, Edward "Sandy" Arnlund, who farmed near Osseo Road and Zane Avenue, began irrigating potatoes in 1934 and 1935. Aaron Tessman irrigated 55 of his 80 acres. By purchasing motors, pumps, pipes, wiring, poles, and water lines to the tune of $4,300, along with a $200 monthly bill for gas, oil, and electricity, his 40 acres produced four times more. To the left, Edmund Tessman's improvised system irrigates the field in 1937. (Courtesy of Alice P. Tessman/Brooklyn Historical Society.)

Farther southeast in Brooklyn Center, Al Rydeen and Bernard Keefe introduced irrigation with small pipes carrying the water built up on a frame. Roy Howe was also laying larger pipes between rows of potatoes. After World War II, heavy steel pipes were replaced with lighter ones. Farm families got up each night for rotation every three to four hours. Edmund Tessman's irrigation system heavily sprayed his potato fields. (Courtesy of Alice P. Tessman/Brooklyn Historical Society.)

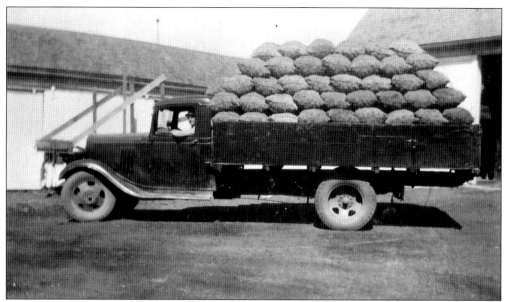

In 1938, Edmund Tessman (above) delivered 166 sacks of potatoes and 277 bushels in his 1935 Chevrolet truck. The families of Harry Gray, Harvey H. Goetze, John Schreiber, and Eldon and Alice Tessman, all fourth-generation farmers, were "skilled in coaxing high yields from the sandy soil." By 1970, Brooklyn Park had 98 farms covering 7,825 acres. The Minnesota Department of Agriculture reported, "The effect of this high fertilization, mechanization and irrigation" created high yields worth $1.3 million. (Courtesy of Alice P. Tessman/Brooklyn Historical Society.)

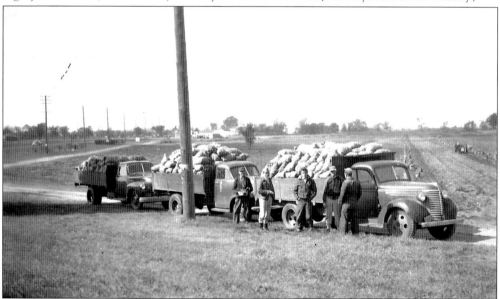

Brooklyn Center gardeners, like the Keefe family (above), sold their farms when city sewer systems increased taxes. During the 1970s, a common sight in Brooklyn Park was a 200-foot boom sprinkler spraying 500 gallons per minute on the crops within sight of Minneapolis's skyscrapers. Potatoes were planted, cultivated, sorted, washed, and bagged without human hands. Calvin Gray was the last commercial potato grower. He stopped tilling his fields in 1992. (Courtesy of Pat Rice Keefe/Brooklyn Historical Society.)

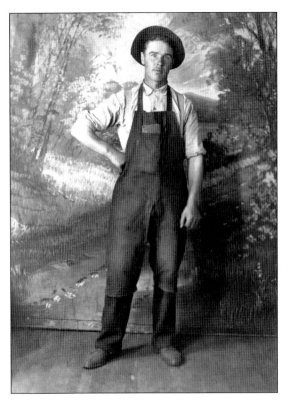

Many Brooklyn farmers considered themselves gardeners, such as Gust Anderson in the gardener's uniform at left and Bernard Keefe, who grew a variety of produce, including potatoes, celery, tomatoes, and so on. As crops ripened, the vegetables or fruits were picked and collected in bushel baskets in the market wagon. Baldwin "Baldy" Hartkopf described a typical farmer's market day as beginning at 1:00 a.m. to feed and harness the horses. (Courtesy of Rose Sandholm/Brooklyn Historical Society.)

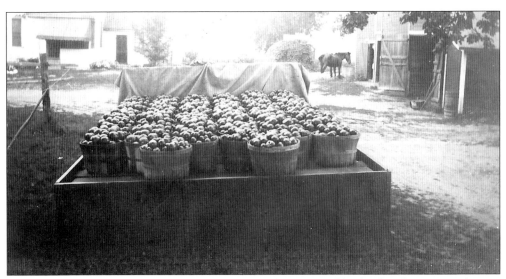

With oats and hay for his horses, Hartkopf's father then covered his load with canvas to keep it fresh during the three-hour ride to Minneapolis. By 5:00 a.m., he reached the old market place on Third Street. Horses were unhitched and boarded for 25¢ at the Holden Avenue barn. Tomatoes (pictured above) were displayed, negotiations began, and sales took place by 9:00 a.m. Farmers returned home for a noon feast. (Courtesy of Pat Keefe Rice/Brooklyn Historical Society.)

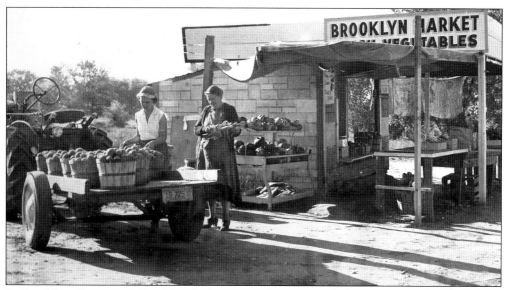

In Brooklyn Center and Brooklyn Park, everyone experienced the sweetness of corn and the freshness of green peppers, dill, cucumbers, and tomatoes. As workmen returned home from their jobs in Minneapolis, Camden, and Anoka, they could stop at the West River Road market stand run by the Gus Larson family in the 1940s. Pictured are Alice Olson Larson (left) and her mother-in-law Hulda Larson. (Courtesy of Brooklyn Historical Society.)

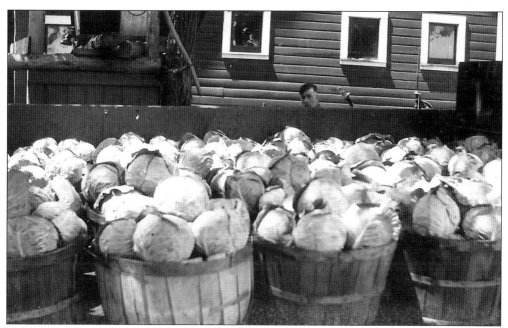

Frank Keefe (pictured) and his brothers packed a load of cabbages for the farmers market. An open farmers' market has been on the north side of Minneapolis since the early 1850s. It continues to offer fresh produce to people in the Twin Cities to this day. All garden produce is offered at the farmers' market, along with flowers. During the holidays, pumpkins, bittersweet, wreaths, and Christmas trees are sold. (Courtesy of Brooklyn Historical Society.)

Pat Keefe Rice shared market gardening memories of two generations of her family. The Heidenreichs and Keefes farmed in Brooklyn Center between the Brooklyn Farm and Mound Cemetery. Each winter, Bernard Keefe kept a map of what crops would be planted on his property along with where the irrigation pipes would best assist the crops. Rhubarb, asparagus, corn, potatoes, watermelon, squash, tomatoes, and green peppers were favored crops. (Courtesy of Pat Keefe Rice/Brooklyn Historical Society.)

With their own greenhouse attached to the house, the Keefes started their seedlings while snow was still on the ground. Planting boxes were layered with a manure and straw spread and topped with the seed boxes. The boxes were filled with soil, and seeds were planted for germination. The combination insulated and fed the seedlings until warmer weather and planting time. (Courtesy of Pat Keefe Rice/ Brooklyn Historical Society.)

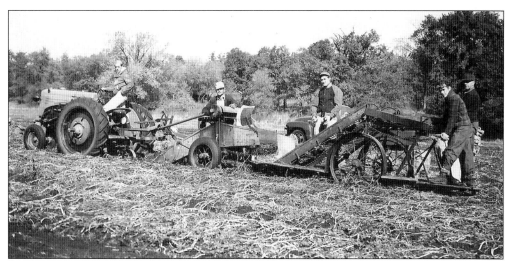

At various times during the planting year, the whole family turned out to help. Especially important were spring planting and the harvesting season. For the Heidenreich and Keefe families who had no sons, it was even more important that everyone came out to help. Pat Keefe Rice claimed her mother was famous for the straight rows she could plow while driving the family's Allis-Chalmers tractor. (Courtesy of Pat Keefe Rice/Brooklyn Historical Society.)

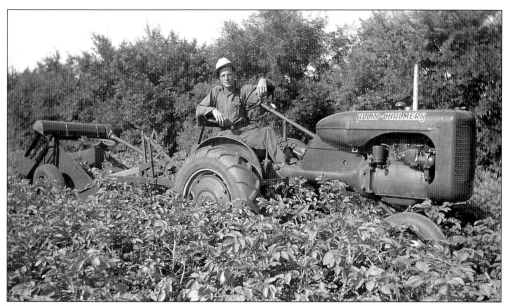

The purchase of farm equipment was very important. Buying a new Allis-Chalmers tractor and a new digger were huge events in the life of Brooklyn farmers like Bernard Keefe (above). Equally important were the digger and the irrigation system from Wisconsin. Photographs were taken to capture the importance of these tools and the success of their enterprise. (Courtesy of Pat Keefe Rice/Brooklyn Historical Society.)

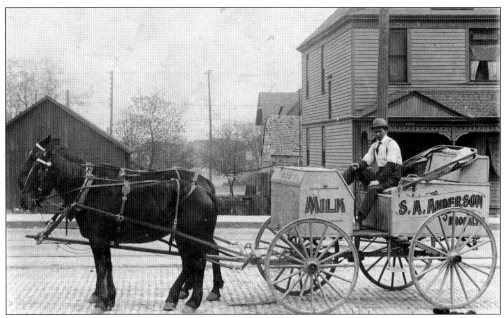

Milk deliveries were made to Camden Place just south of Brooklyn. Housewives set out a pan or jar and milk tickets. In 1892, 15 quarts cost $1. Since there were no refrigerators, lots of recipes called for sour milk. Swan A. Anderson (pictured) farmed off Seventy-third and Dupont Avenues. He and his son Arthur N. Anderson delivered milk in the late 1890s and early 1900s to North Minneapolis. (Courtesy of Mrs. Rolland Anderson Holmberg/Brooklyn Historical Society.)

By 1880, Brooklyn Township had enough cattle to warrant a slaughterhouse. This was the slaughterhouse built by Daniel Mosher off Fifty-sixth Avenue and Osseo Road and later owned by Fred and Dan Libby. Local historian Sig Edling remembered driving cattle along this road to be slaughtered "in his younger days." The building burned down in 1978 and was the last slaughterhouse in Hennepin County. (Courtesy of Leone Howe/Brooklyn Historical Society.)

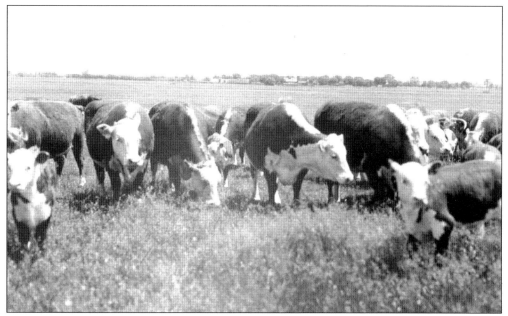

Many Brooklyn farmers also had herds of cattle. From the 1930s through the 1950s, the people of Hennepin County enjoyed viewing the 200 Hereford cattle on Earle Brown's ranch, known as the Brooklyn Farm (pictured). Richard Christofferson fondly remembered, "Just about every Saturday I walked over to Earle Brown's farm where I sat by the white fence, ate a picnic lunch, and watched the white-faced cattle graze." (Courtesy of Earle Brown/Brooklyn Historical Society.)

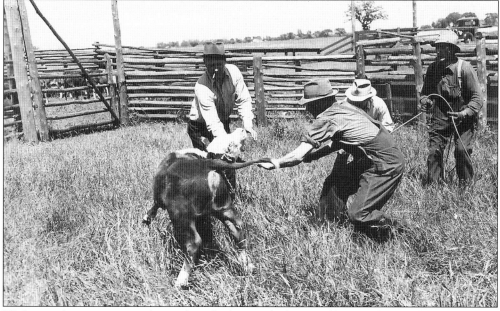

With a ready access to nearby stockyards, farmers had no problem marketing their cattle. Just south of Brooklyn Township was the 10th Ward District of Minneapolis, the largest stockyard in the county. In 1880, 6,000 head of cattle passed through the stockyard. Closer to home on the southwest side of Brooklyn Township was the slaughterhouse. (Courtesy of Earle Brown/ Brooklyn Historical Society.)

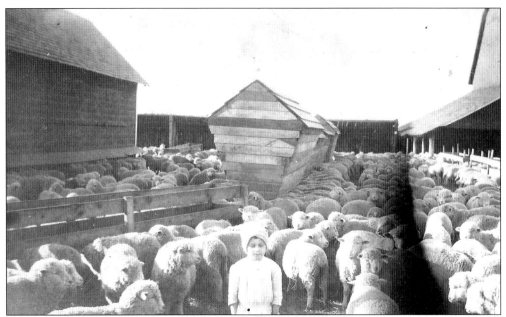

In 1893, Edward Egan bought 100 sheep and planned to see how they would fare during the winter, an off time for Brooklyn's potato farmers. The next year, he traveled to Montana and brought back 1,000 sheep to feed through the winter. Sheep became Brooklyn's collateral industry. By 1907, 25,000 sheep wintered with 28 Brooklyn farmers. Etna Schreiber (pictured) looks as cuddly as the Schreiber sheep in 1910. (Courtesy of Vera Schreiber/Brooklyn Historical Society.)

When potatoes were shipped, Montana farmers sent sheep. A lamb arrived weighing 65 to 70 pounds and stayed all winter. It ate hay and hulls from wheat or rye grain and weighed 100 to 105 pounds in the spring. Aaron Tessman trucked his sheep to the South St. Paul stockyards. Others herded them to Osseo and shipped by train. In the meantime, the fertilizer by-product nourished the seed potatoes. (Courtesy of Earle Brown/Brooklyn Historical Society.)

In 1917, World War I brought a shortage of wool needed for uniforms, socks, overcoats, and blankets. The Minnesota State Fair increased premiums to the owners of purebred sheep. Since 1909, the number of sheep in Minnesota had been on the decline. The good news that year was that the value of sheep was up 40 percent from the previous year. In this photograph, Archie Eidem cares for his sheep in the early 1920s. (Courtesy of Eidem family/Brooklyn Historical Society.)

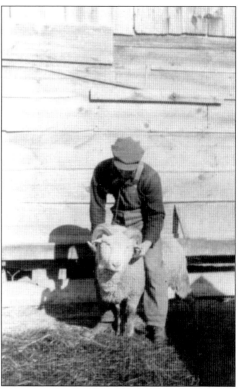

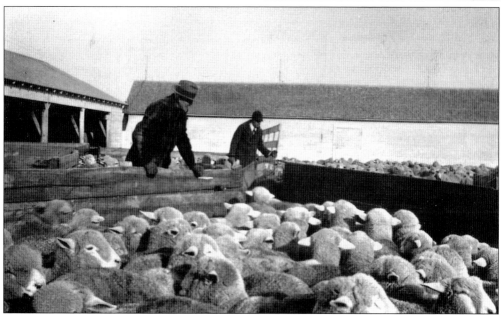

Because of the marvelous 4-H directors, many Hennepin County children belonged to 4-H. In the late 1930s, Mary (Koch) Keogh and Kathryn (Koch) Martens received lambs from their grandfather and cared for them in the woodshed. They fed, watered, and carded them. In July, they took them to Hopkins for a showing. To the girls' surprise, the sheep received blue and red ribbons for first and second place. (Courtesy of Alice P. Tessman/Brooklyn Historical Society.)

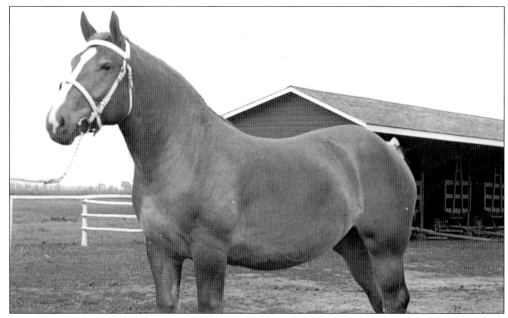

Earle Brown traveled worldwide to find the best Belgian horses. One of his more famous horses was Genese de Ergot (pictured). In 1926, Genese de Ergot was named senior and grand champion at the international show in Chicago. From 1928 to 1931, she won senior and grand champion honors. In 1933 and 1934, the mare was named reserve grand champion at the world exposition. Brown's records remain unbroken. (Courtesy of Earle Brown/Brooklyn Historical Society.)

Each summer, Brown showed his sleek horses, such as Temptation (pictured) or Genese de Ergot. In the Minnesota State Fair's horse barn, monogrammed robes, flags, and ribbons draped the stalls, a symbol that the Brooklyn Farm was a top breeder of horses. Brown was a Minnesota State Agricultural Society member, was vice president of the Minnesota State Fair from 1944 to 1954, and was elected into the fair's hall of fame. (Courtesy of Earle Brown/Brooklyn Historical Society.)

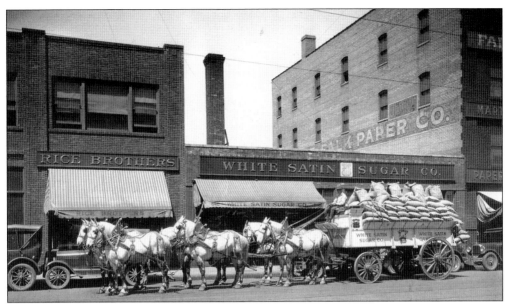

One of the goals in raising horses was to breed an identical team of horses. It was difficult breeding two identical horses. To get six identical horses was almost impossible. As with the famous Anheuser-Busch Clydesdale horses, Brown bred a prize team of pure white horses (pictured) in the early 1900s and sold it to the White Satin Sugar Company at 1044 Marquette Avenue in Minneapolis. (Photograph by Norton and Peel; courtesy of Brooklyn Historical Society.)

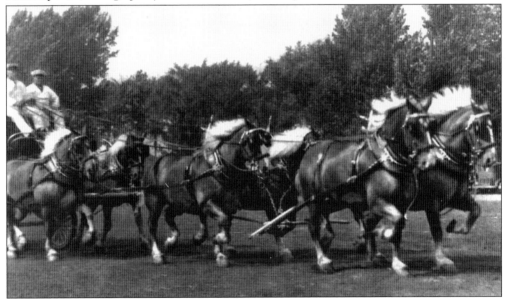

The Brooklyn Farm was known worldwide for its exceptionally bred horses. Above is Earle Brown's "Famous Belgian Six." The award-winning six-tem and eight-team horses competed at county and state fairs across the country. Brown built his E barn with the exact measurements of the Minnesota State Fair's hippodrome so he could have his team and drivers execute the exact turns while keeping a consistent pace. The teams showed the precision needed for beer wagons to make turns on downtown street corners. (Courtesy of Earle Brown/Brooklyn Historical Society.)

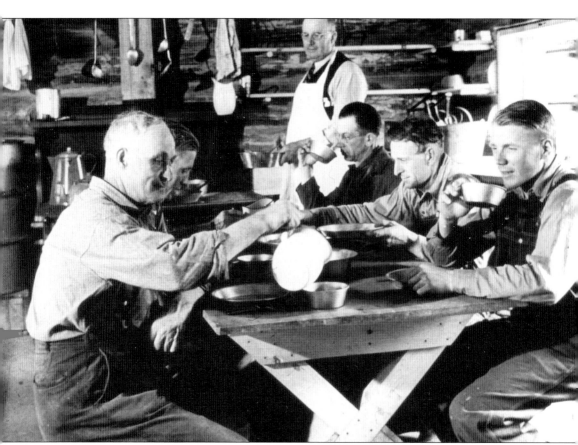

With farmers traveling to Minneapolis or depots to load or sell produce, hired hands were needed to perform daily farm chores in their absence. By the early 1900s, the hired men were paid $25 a month along with their room and board. Earle Brown hired 15 employees, including, from left to right, Oscar Smith, three unidentified, Leo Koch, and Carl Swing. Five teams went out daily to plow or cultivate fields. Koch, Earle Brown's personal gardener, earned $75 per month, along with food, water, firewood, and a house for his family. He was responsible for starting the cookstove fire at 5:00 a.m., milking the cow, maintaining the English flower and vegetable gardens, and growing lettuce, asparagus, carrots, brussels spouts, and so on for Brown, the chauffeur and foreman households, hired hands, and his own family's table. (Courtesy of Earle Brown/Brooklyn Historical Society.)

In the 1860s, the Brooklyn Township officials increased the amount of money in the treasury by charging a registration fee of $1 for each dog. Farmers readily paid the charge. The Schreibers' and Marin Knoble's dog names were Prince and Duke, respectively. John Jenkins registered Sagin. George Smith's dog was Rover, Silas Merrill's was Tip, and Moses Dubukue's was Tippy. Romeo (pictured) was someone's beloved pet in the 1880s. (Photograph by P. Jurgens Photography; courtesy of Brooklyn Historical Society.)

Some dogs worked. Edmund Tessman's dog Kelly (pictured) worked hard during the heavy snow of 1934. But Brooklyn had its wayward pets. A 1917 newspaper reported, "A dog with a taste for mutton got into W. H. Curtis' sheep yard last Thursday night killing two sheep and injuring three more." By 1974, Brooklyn Park logged 1,686 animal complaints, 65 bites, 1,056 licenses, and 473 dogs impounded. (Courtesy of Alice P. Tessman/Brooklyn Historical Society.)

Earle Brown loved animals so much that he built an animal cemetery. According to his cousin Margaret Watts Brown, his dog was trained to sit at the piano, bang on the keys, and sing. The dogs would escort Anna (Oakland) Koch home in the evening after a visit with the Browns. Once the dogs returned, the lights in the lane would be turned off. Earle Brown and his wife, Gwen, are pictured above. (Courtesy of M. Babcock/Brooklyn Historical Society.)

Much has changed since Earle Brown lived on the Brooklyn Farm; however, pets are still loved. Brooklyn Center does not require a dog license, but today's pets must have a name tag fastened to their collars with their owner's name and telephone number. Brooklyn Park charges $5 for a dog license or $15 if the dog is not neutered or spayed. Both towns require rabies vaccinations and have leash policies. (Courtesy of Earle Brown/ Brooklyn Historical Society.)

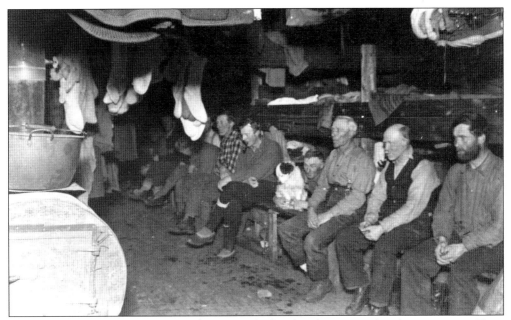

In 1851, loggers (pictured) were paid $15 a month plus their keep to work in logging camps. From mid-November through April, the lumberjacks lived in tar paper and lath buildings. Men packed belongings in turkey sacks, seamless grain sacks that contained "gray darning yarn, spools of heavy white and black thread, a large bag of horehound candy, and Hoff's German liniment—made by a doctor at a drugstore in Anoka." (Courtesy of Anoka County Historical Society.)

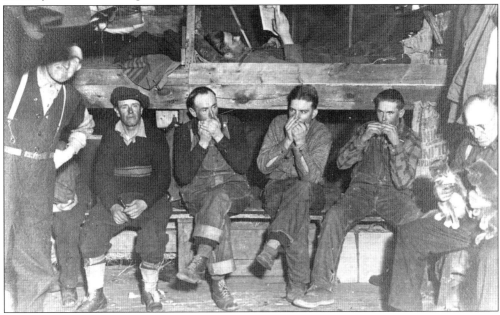

A five-foot barrel stove kept the men warm, and the sand island around it served as a spittoon. Men slept in two-layer bunks, two to a bed, that were four by seven feet and covered with hay, blanket "mattresses," and two blankets on top. With such tight quarters, lice, fleas, and bedbugs spread rapidly. Balsam branches over the mattresses reduced the bedbug problem. (Courtesy of Ike Anderson/Brooklyn Historical Society.)

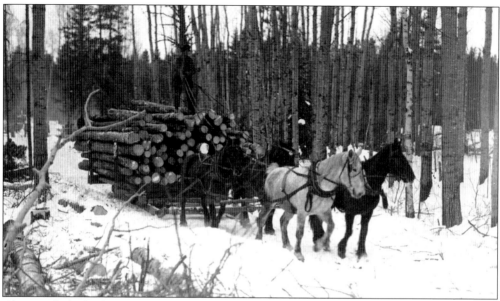

Along with the lumberjacks were saw filers, swampers, and sawyers. Saw filers filed and sharpened the huge crosscut saws so lumberjacks could cut through a tree in one or two cuts. Swampers cut trails and trimmed branches from the sawed trees for $35 a month. And a sawyer cut trees into logs for $60 a month. The sawyer could cut as many as six 16-foot logs from a tree. (Courtesy of Earle Brown/Brooklyn Historical Society.)

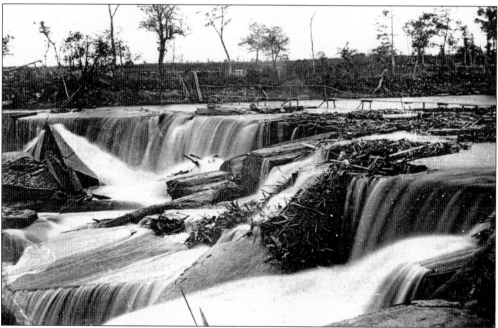

Sleighs similar to the one in the previous photograph, which has 8-foot-wide runners and 14-foot-wide bunkers, brought logs to the river. The horse teams pulled loads of 10,000 to 15,000 board feet of logs. Sleigh roads were gouged out before the frost by a rut cutter. The icer frosted ruts with water, leveling out corduroy roads. Logs traveled down the Mississippi River to St. Anthony Falls where hundreds at a time piled up. (Courtesy of *The Geology of Minnesota*.)

Men from Brooklyn Township traveled north to Blackduck, Ball Club, and Bena logging camps. Over 100 men worked as loggers in each camp under a camp manager. Cooks prepared meals of meat and potatoes while the cookee steamed vegetables and waited tables. Each man brought his own pitcher of mottled blue or gray graniteware for drinking and washing. (Courtesy of Earle Brown/Brooklyn Historical Society.)

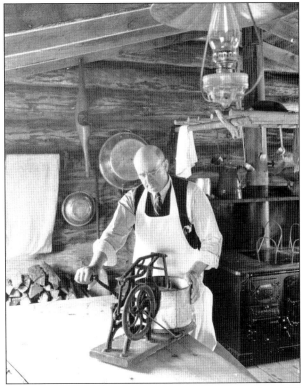

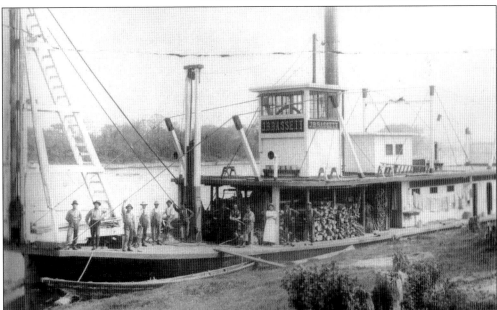

Mary Woodbury Caswell lived near the Mississippi River above Brooklyn Township. She recalled visiting Elias Pratt, superintendent of the logging division, on a wanigan (pictured). Pell McClure, the cook, made her a lunch of "plain cake very heavily flavored with lemon extract. Now, if there is one flavor I absolutely loath, it is lemon juice of the bottled variety, but at that time this cake completely satisfied my idea of ambrosia." (Courtesy of Anoka County Historical Society.)

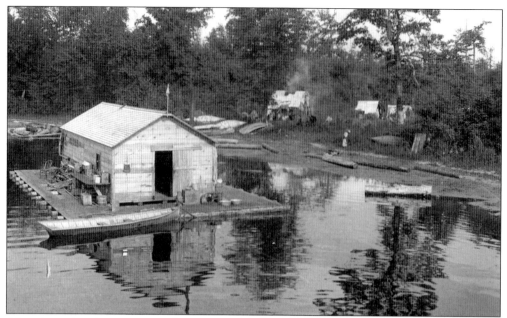

After the spring thaw, wanigans became active. Resembling a scow with a flat hut in the middle, the boats carried cooking, eating, and sometimes sleeping facilities. The wanigans followed the log drive from Mille Lacs Lake downriver, unjamming and catching stranded logs. When the log drive ended at the boom houses above the St. Anthony Falls, a steamer pulled the wanigan back up the river to begin another drive. (Courtesy of Earle Brown/Brooklyn Historical Society.)

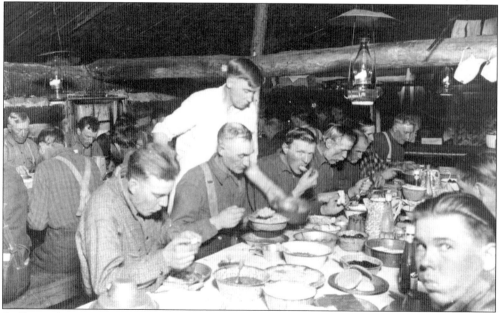

Coffee and tea were made at the lunch site. If the loggers were over a mile from the camp, the cookee brought hot lunch in a "swing-dingle" sleigh that had various shelves and partitions for the food. The men then took a break for half an hour. Food included caribou, moose, and deer. Prunes were served at most meals along with fresh bread. Raisins were served in puddings. (Courtesy of Ike Anderson/Brooklyn Historical Society.)

According to the 1914 *Farmers' Directory of Anoka-Hennepin County, Minnesota*, Franklin Steele, J. G. Lemon, S. W. Farnham, Ard Godfrey, Joseph Libby, and George Washington Getchell founded the Mississippi and Rum River Boom Company (near No. 13 on the map to the right) at Fifty-seventh and Lyndale Avenues on March 21, 1857, with a capital of $15,000. Loggers directed logs downriver for sorting with pick poles, or pikes, to push or hold back logs and used the shorter cant hooks, or peavey poles, to turn them. (Courtesy of Brooklyn Historical Society.)

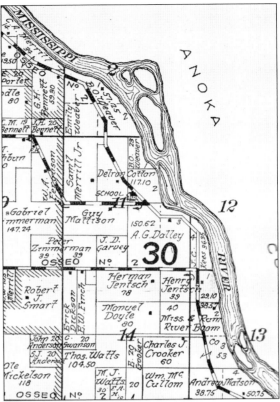

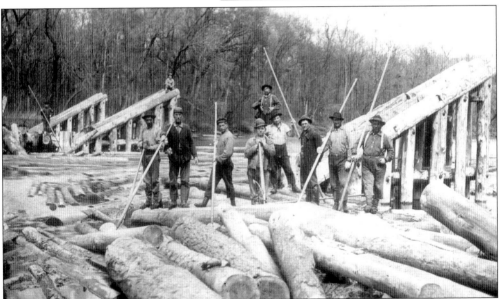

During the boom house sorting, a catch marker looked for branded logs and notched the ends. As catch marker for the C. A. Smith and Company sawmill, Ike Anderson (pictured third from right) fastened nails to the bottom of his shoes for traction. "Although we were pretty good at hopping from one rolling log to another all day long, we sometimes fell in." (Courtesy of Ike Anderson/Brooklyn Historical Society.)

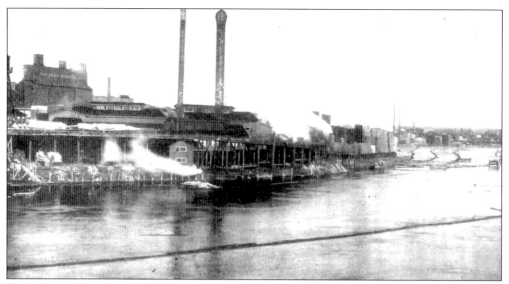

Ike Anderson's long-handled, light ax made four chops to create C. A. Smith and Company's mark of two square diamonds. For this, he earned $1.75 a day. The former sawmill district of Minneapolis in the early 1900s looked similar to the photograph above with the Shevlin-Carpenter Company mill and office at the foot of Fourth Avenue North. Boom dividers are faintly visible where companies routed branded logs into their owners' mills. (Courtesy of Brooklyn Historical Society.)

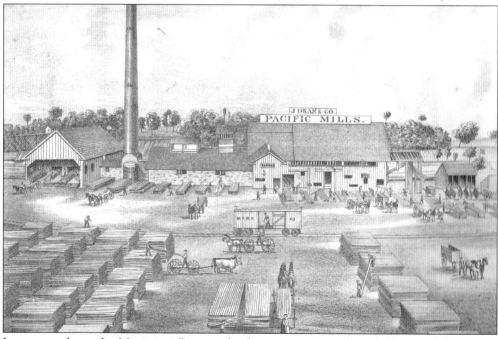

Logs came down the Mississippi River to lumber companies such as J. Dean and Company, C. A. Smith and Company on Forty-fourth Avenue, Bovey DeLaittre on Fortieth Avenue, Bockus-Brooks Northland Pine on Thirty-second Avenue, Akeley on Twenty-eighth Avenue, and Carpenter Lamb. Logs were cut into lumber, millwork, or lathe. The John Martin Lumber Company ran from 1875 to 1887, when it was destroyed by fire. (Courtesy of Brooklyn Historical Society.)

Another significant business in Brooklyn Center was ice harvesting. Prior to propane gas generators or electrical refrigeration, the public relied on blocks of ice to keep foods from perishing in the iceboxes. Cedar Lake Ice Company, founded in the 1890s, was just one of the companies that harvested ice from Twin Lake and the Mississippi River. (Courtesy of Minnesota Historical Society.)

Harvesting began when ice companies staked claims on a lake. Next, ice was cultivated by scraping the snow off the ice to become thicker. Once the ice was 18 inches thick, plows cut the ice into 22-by-32-inch cakes that weighed 440 pounds. Local icemen removed up to 18 cakes a day from local lakes. Once over 75,000 tons were taken from Twin Lake in Brooklyn Center (pictured). (Courtesy of Minnesota Historical Society.)

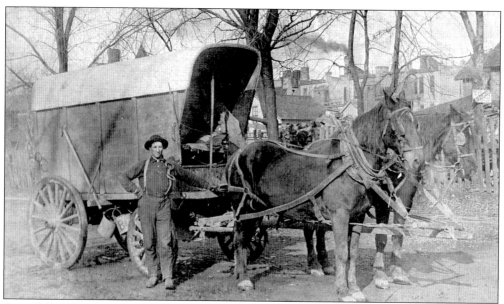

One of the Village of Brooklyn Center's first ordinances banned icehouses. It was feared that the sawdust packed around the ice blocks would create spontaneous combustion. Inhabitants relied on vendors rather than a personal supply. After the annual harvesting of 1913 was completed, King McCausland (pictured) distributed the ice door to door. Housewives left cards in their windows, indicating whether they wanted a 25- or 50-pound block of ice. (Courtesy of Leone Howe/Brooklyn Historical Society.)

Ice was also delivered to hotels, the *Minneapolis Tribune* offices, and department stores. According to local iceman George Nassig (pictured), Dayton's, a Minneapolis department store, had a tearoom on the eighth floor that served ice cream in the 1930s. Ice was delivered there three times a week at a cost of $6 a ton. Commercial businesses paid $12 a ton. (Courtesy of Brooklyn Historical Society.)

*Four*

# PATRIOTIC AND FASHIONABLE FAMILIES

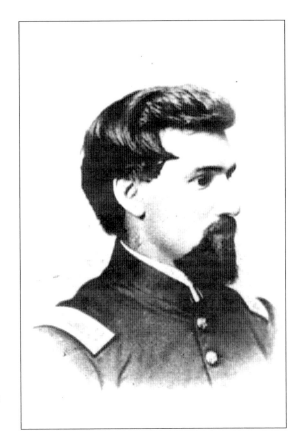

Over 200 men served in the Civil War from the Brooklyn area. In April 1861, 40 men answered Pres. Abraham Lincoln's initial call. The 1st Minnesota Volunteers fought at Bull Run, Antietam, and Fredericksburg. From Gettysburg, John W. Plummer wrote, "When we got back to the Colors, where we rallied, and scarce twenty-five men were to be found. Most who went in were killed, wounded, or helping off the wounded . . . few officers were left." (Courtesy of Minnesota Historical Society.)

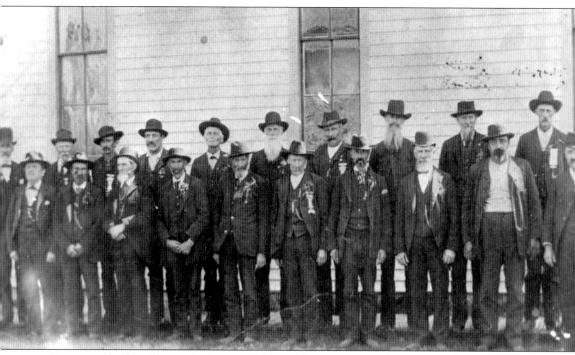

Devastated by drought and famine, the Dakota Indians attacked Minnesota settlers on August 17, 1862. Within weeks, they killed 400 to 800 people. The annuity for the Dakotas arrived at Fort Ridgely on August 19, too late to stop the devastation. Following the battle, Chief Big Eagle said, "We thought the fort was the door to the valley as far as to St. Paul, and that if we got through the door nothing could stop us this side of the Mississippi. But the defenders of the Fort were very brave and kept the door shut." During the winter, the new regiments defended frontier borders and harvested crops left to rot when settlers fled their farms. Above are surviving members of the William Grant Post of the Grand Army of the Republic in Osseo in 1898. (Courtesy of Osseo Preservation Society.)

While their men left and fought the Confederates or protected the Minnesota borders, the women "kept the home fires burning." In their husbands' absence, they continued farming and found food for the family. Women laid their muskets across the plow handles for protection and prayed for their husbands' return. Here a Ms. Setzler and John Plummer pose during the war. (Photograph by E. Decker; courtesy of Brooklyn Historical Society.)

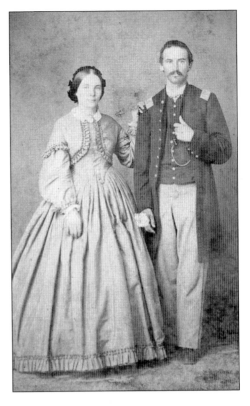

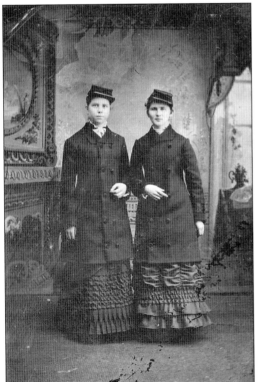

Fortresses were constructed in small towns throughout Minnesota. In Brooklyn, Horatio R. Stillman "bundled his family into his wagon and took them to Minneapolis." Others gathered at the Steven Dutton farm to build a "small fortress." Osseo settlers built a 30-by-30-foot fort at St. Vincent de Paul. Men took turns as watchmen. One false alarm sent everyone scurrying in fright when a small herd of stray cattle approached. (Courtesy of Brooklyn Historical Society.)

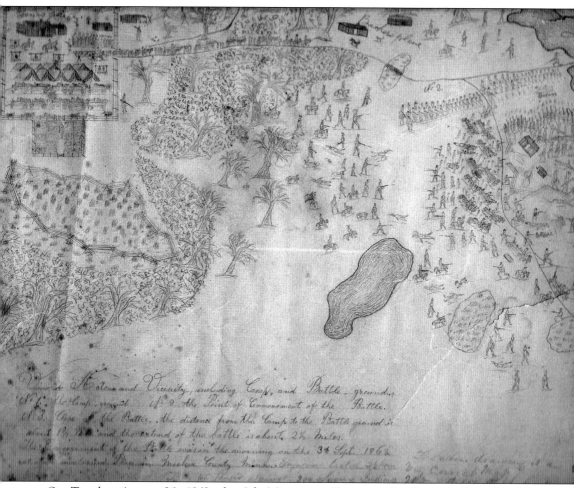

On Tuesday, August 26, 1862, the 9th Minnesota Company B volunteers from Brooklyn Township included William H. Brown, James H. Crandall, Alvah Getchell, Henry Goodale, Winter Jacques, and John B. Wakefield. Equipped with old muskets, they marched to Acton, the site of the first murders. Led by Little Crow and Walker Among Sacred Stones, 200 Dakota Indian warriors camped nearby. As the soldiers prepared for battle, they found the wrong ammunition and shaved minié balls down to fit throughout the night. Early on the September 3, Capt. Richard Stout marched his 65 men onto the plains. The Dakota Indians aimed their Springfield rifles and fired. Private Getchell, Pvt. George W. Gideon, and Pvt. Edwin Stone fell, mortally wounded. The rest of the regiment charged through the warriors. Wounded soldiers fell into the supply wagons as they fought their way to Hutchinson. Seen here is an 1862 sketch by Pvt. E. D. Kirst of the 9th Minnesota Volunteer Regiment. (Courtesy of Brooklyn Historical Society.)

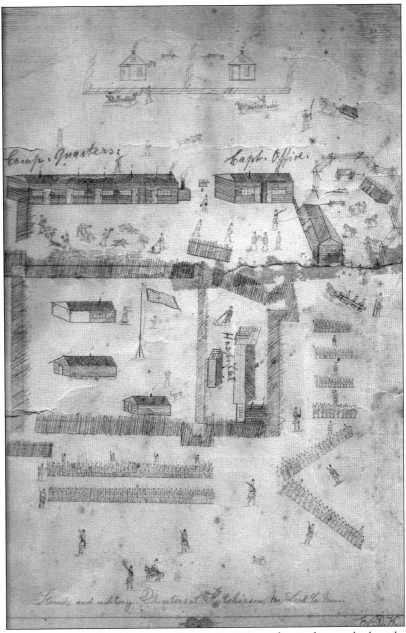

The fort was completed at Hutchinson on August 27, 1862, with a timber stockade eight feet high that sheltered over 400 settlers. The 9th Minnesota Volunteer Regiment Company B arrived just in time for the attack on September 4. After this last major attack, the Dakota Indians headed into the Dakota Territory. The regiment remained in quarters at Fort Hutchinson throughout the winter to heal wounds and protect settlers. Brooklyn's Levi Merritt and Winter Jaques were among the wounded. Kirst drew a diagram of Fort Hutchinson during the winter, indicating the various activities performed by the soldiers, including marching, inspection, chopping wood, and guard duty. The next year, the men were sent south and faced the Confederates during the last couple years of war. Many were sent to Andersonville Prison following the battle of Gunstown on June 10, 1864. (Courtesy of Brooklyn Historical Society.)

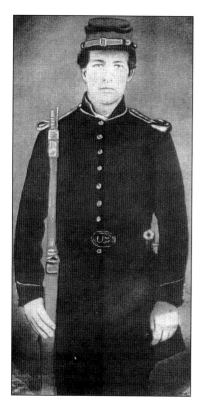

Alfred Gervais (pictured) was the son of Louis Pierre Gervais and Marie Tremblay, who emigrated from Quebec, Canada. He was inducted into the 5th Minnesota Volunteer Infantry Company F on January 22, 1862, and was wounded the following spring at the battle of Corinth. When his father arrived to bring him home, he had changed so much in appearance that he was unrecognizable. (Courtesy of Gervais family/Brooklyn Historical Society.)

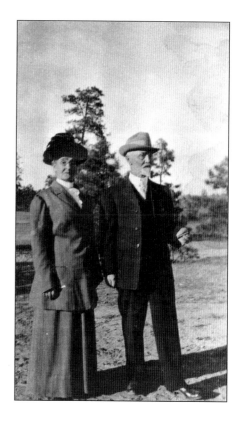

In 1855, John William Pride (pictured) arrived in St. Anthony and worked in the mills until he enlisted as a private in the 1st Minnesota Volunteer Infantry on April 29, 1861. He was wounded at Bristow Station, captured during the battle of Petersburg, and barely survived Andersonville Prison. Pride's patriotic story is much like that of his fellow Brooklyn Civil War soldiers. (Courtesy of Brooklyn Historical Society.)

When a traveling photographer came to the farm, everyone gathered outside with all their pets, birds in birdcages, valuable bicycles, carriages, and horses. In May 1916, 7,200 photographs were taken of people in Osseo and the surrounding Brooklyn area. Photographers snapped public buildings, stores, banks, residences, and farms "to show the greatness of Hennepin County." This photograph of a Brooklynite was taken by the Beal studio. (Courtesy of Brooklyn Historical Society.)

Other memorable moments were captured in studios like Beal's Photographic Studio (pictured) located at Washington Avenue between Nicollet Avenue and First Avenue South in Minneapolis. Another favorite was the William Brown Studio at 41 Washington Avenue in the Merchant's Block of Minneapolis. Families also traveled to St. Paul or nearby Anoka to have their photographs taken. (Courtesy of Brooklyn Historical Society.)

Martha Gervais Bottineau and her French Canadian sisters (pictured) wore clothes similar to Therese LaBissoniere, including "a wool knit bonnet, tied under her chin; it had a small black bow on the top and one at the back of the neck. . . . Her outer clothing was . . . a 'cloak' of brown wool cloth, lined with red flannel, very plain, ankle length and buttoned all the way down. . . . She wore a heavy wool shawl, folded cornerwise and coming down below her waist. She wore low 'Martha Washington' shoes, with rubbers, and long black hand-knit hose. Her dress was full skirted, with a fitted bodice, high necked and long sleeved, of black cotton with a white dot in it; under this she wore two or three full woolen petticoats but no underwear except a long white muslin chemise with half sleeves and which hung just below the knees." (Courtesy of Brooklyn Historical Society.)

Inspired by his wife, Charles Dana Gibson created the Gibson girl look in 1901. This early Edwardian fashion featured a swanlike figure with a straight front corset, forcing the body into an S-bend. Satin fabrics gracefully flowed along these unique lines. Gowns had the flowing seven-gored skirt, while feathers adorned their wide-brimmed hats, and multifaceted black jet beads decorated bodices. Rena Rochat, seen in this photograph, depicts Gibson girl traits. (Photograph by Rembrandt Studios; courtesy of Brooklyn Historical Society.)

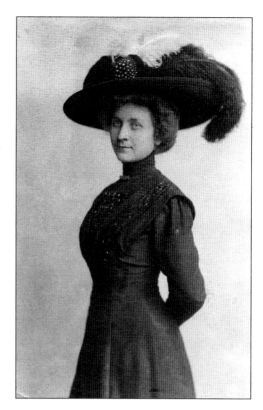

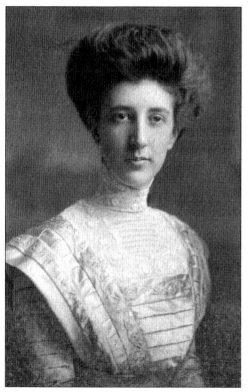

A bouffant roll of hair bordered the face with the length wrapped up into a knot in the back. Pompadour hair with the large hats added to the Gibson girl prominence at the dawn of the 20th century, as seen by these two Brooklyn women. The high-built collars accentuate the stiff posture, adding to the special swan appearance. Satin brocade, pleats, embroidered trim, laces, sequins, and exotic trims were desirable. (Courtesy of Brooklyn Historical Society.)

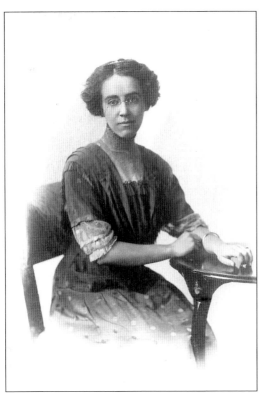

Alma Doten (pictured) graduated in 1910 dressed in a softer Edwardian style popular from 1900 to 1920, with a dark, pleated, small print silk skirt. The dropped waist with the satin and fringe trim indicates the end of the Edwardian era but that she was still trying for a thin waist. Although the sleeves are still slightly gathered and the high-built collar is present, the lace and pleats depict a graceful woman. (Photograph by Lee Brothers; courtesy of Brooklyn Historical Society.)

The flapper fashion made popular by such books as *The Great Gatsby* was represented by hair cut short and permed into finger-wave curls. Shift dresses in silk and crepe were short and rouged knees appeared. The cloche-style felt hat became popular. The ragtime era of the 1920s featured a lot of furs, especially the muskrat coat. The advent of the car led to a relaxed lifestyle away from conservative clothing. (Courtesy of Brooklyn Historical Society.)

By the mid-1800s, children were no longer forced to wear adult clothes cut into smaller sizes. With the smallpox vaccine, parents developed natural attachments to their children. With the Industrial Revolution, clothes, shoes, and toys were made specifically for children. This photograph depicts the Buhrman baby in a rather plain but comfortable white flannel gown and receiving blanket being worshipped by her father and loved by her mother, Florence Schmidt Buhrman. (Courtesy of Brooklyn Historical Society.)

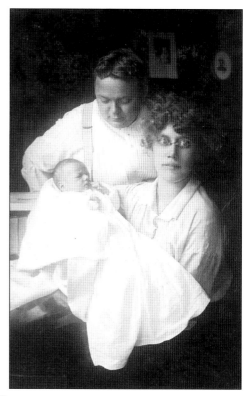

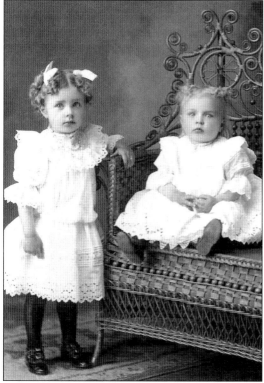

Marie and Esther Buchholtz (pictured) are dressed in Edwardian styles of 1907 still influenced by the British royalty. Dresses were made of white cotton or lawn with large white collars, pin tucks, and ruffles. Long hair in ringlets or curls pulled back by large bows was fashionable. Sleeves were gathered, doubled, and winged at the shoulder to add a decorative flair. Black knit stockings kept girls warm and modest. (Courtesy of Brooklyn Historical Society.)

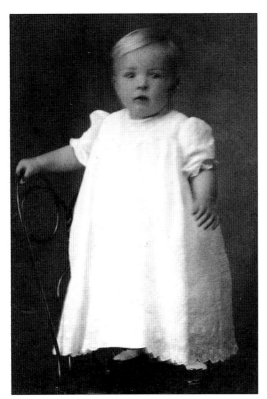

By the 1900s, the Buster Brown style was fashionable. Named after the cartoon character, the outfit featured a blousy, Russian-style shirt with a velvet jacket, short pants, and accented with a huge bow tied at the neck. Also called the Little Lord Fauntleroy style, this outfit survived a number of years. The style was an improvement over the earlier gown (pictured) that was worn by Walter Buchholtz. (Photograph by Nelson Photography; courtesy of Brooklyn Historical Society.)

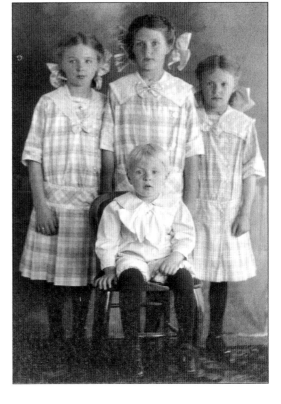

Until a boy was five or six, he wore infant gowns just like his older sisters. In the early 1900s, Buchholtz's sisters Marie, Esther, and Lillian (pictured) probably handed down their outgrown gowns. A couple years later when he reached boyhood, he wore pants. First he wore the shorter pants or pantlets with shoes that look suspiciously like hand-me-downs from his sisters. (Photograph by Nelson Photography; courtesy of Brooklyn Historical Society.)

Three-piece wool suits for boys were standard for formal wear even when worn with knee pants, or the "double knees." Often a boy wore a blue serge paneled front with wide linen bows in the early 1900s. Brass buttons added the extra spark needed for dress wear. Even into the 1930s, farm boys went barefoot all summer long. Most boys had laced leather shoes when winter came. (Courtesy of Brooklyn Historical Society.)

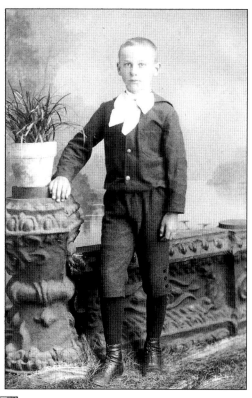

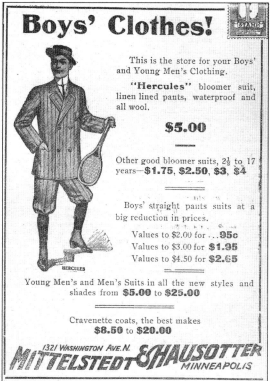

Mittelstedt and Hausotter of Minneapolis called William Godske's outfit (pictured above) a "Hercules" bloomer suit that was for ages 2½ to 17. The suit came lined with linen, waterproof, or wool and was sold for $1.75 to $4. The early-1900s single-buttoned blouson jackets were being replaced by the double-breasted jackets and the Cravenette coat. Godske's outfit features big brass buttons, and he is wearing lace-up boots. (Courtesy of Brooklyn Historical Society.)

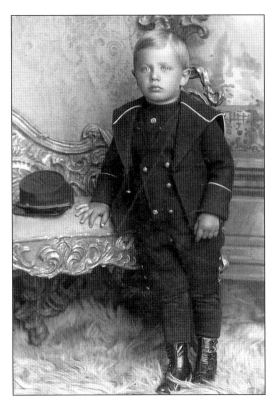

These Brooklyn photographs depict the military's influence on boys' clothes. Until the early 1900s, the sailor suit was worn because of the influence of the younger British royalty, who dressed in middy blouses, pants, and black tie. Often a straw boater's hat or beanie accented the ensemble. At left, John and Martha Champlin's son Archie is dressed in the popular sailor look that went out of fashion during World War I. The British royalty of German descent also lost popularity. He has a slouch or forager cap, a fashion inspired the Civil War soldier's cap. The double-breasted suit, brass buttons, and epaulets on the shoulders further imitate uniforms from that era. The bandmaster's cap, drum, and uniform seen below were influenced by the Civil War. Both boys are dressed in buttoned leather shoes. (Courtesy of Brooklyn Historical Society.)

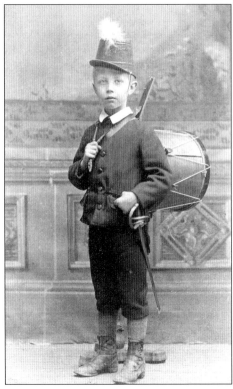

In the early 1900s, blues, tans, browns, grays, and "fancy mixed patterns" were fashionable and formal. Piping on the lapels added a touch of quality. In 1915, spring suit prices were cut more than 50 percent for an excellent bargain at $8.75. Frock coats were still the correct formal wear for men, often accented with a top hat. (Courtesy of Osseo Preservation Society.)

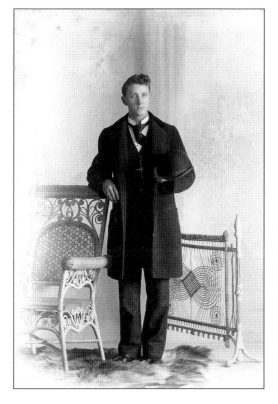

Here Emile Brugger is dressed in a frock coat with a vest, shirt, stand-up color, and black bow tie. He has a formal pose to go with his formal wear and a derby hat perched in his hand. Often men carried a cane as well. He is surrounded by the typical gregarious furnishings of the Victorian era, including the elaborate wicker chair and the macrame railing. (Photograph by Gaugler and Heal Photography; courtesy of Brooklyn Historical Society.)

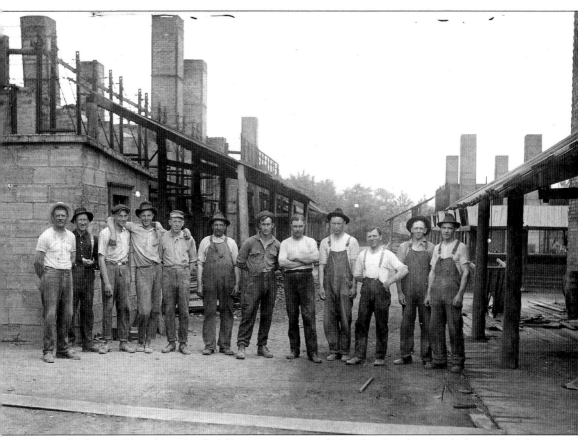

In the late 1850s, when Frank O'Brien went to work for the Crooker family he packed "an extra hickory shirt, a pair of blue overalls." In the 1930s, styles had not changed much. Kathryn (Koch) Martens said of her father, "Dad wore work clothes, sometimes overalls. After Mr. Merriman died, Daddy got all his clothes—a beautiful gray, wool overcoat, Glen plaid suits, and ties to wear to church on Sunday." While crops grew, the Brooklyn farmers sought out other jobs in neighboring towns. Gust Anderson, seen to the far right, farmed west of Osseo Road in Brooklyn Center and worked at the nearby Swanson Brickyard located behind the Camden Pumping Station near the Mississippi River. He wears overalls, a union suit, and, like most in the photograph, a fedora hat. (Courtesy of Brooklyn Historical Society.)

In the 19th century, brides often wore black silk, satin, or brocade like the one worn here by Minnie Dieriks on her wedding day to Leonard Dieriks, a relative of Edmund Tessman. However, bridal gowns came in all colors. For her marriage to George Rochat Jr., Lena Charest "wore a plain blue suit and black hat with a corsage bouquet of yellow roses." Edmund and Louise Setzler Tessman and Ferd Tessman were guests. (Courtesy of Tessman family/ Brooklyn Historical Society.)

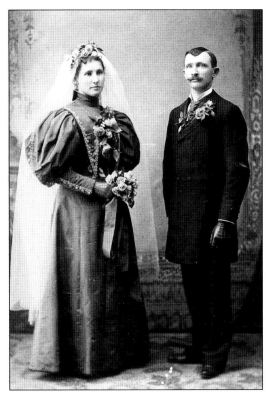

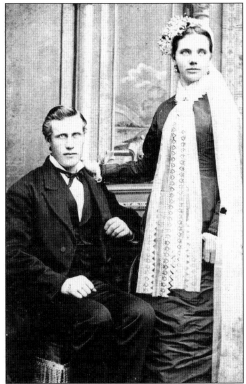

Anton and Pauline Setzler Schmidt pose in formal wear presumably on their wedding. Anton is dressed in a three-piece suit while Pauline wears a black, princess-style satin dress with a wide swag-gathered skirt. Lace cuffs and a long lace collar and tie accent her outfit while a veil cascades to the floor from the cluster of flowers pinned above her ear as the couple happily begins their life together. (Courtesy of Setzler and Schmidt families/ Brooklyn Historical Society.)

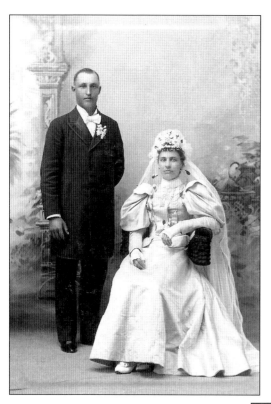

In 1840, when Queen Victoria of England married her cousin Albert of Saxe-Coburg, she wore a white gown, setting a tradition for future brides. White symbolized the purity and innocence of girlhood. August Tessman's daughter Eda married John Schreiber in 1896 to join the two influential Brooklyn families. She wore an elaborate satin gown with a seven-gored skirt, peplum, embroidered bodice, high-neck collar, and billowed sleeves. (Photograph by Nelson Photography; courtesy of Vera Schreiber/Brooklyn Historical Society.)

Gust and Jennie Anderson's wedding party poses here. Jennie is dressed in a shorter gown that was made popular during the Roaring Twenties. It has an armistice-style bolero bodice accentuated by a short ruffle. The gathered skirt is elaborately embroidered. She wears a pearl necklace, crown of orange blossoms, and net ruffles with a cascading net veil and carries a bouquet of roses. (Courtesy of Brooklyn Historical Society.)

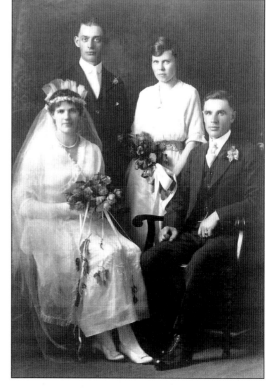

In this photograph, Kathryn (Koch) Martens wears a belted, pleated school dress in front of the gardener's house on the Brooklyn Farm. She recalled the 1930s, "For school we had nice clothes. . . . Overshoes were of black fabric, rubber soles and toes, or buckles or snaps that weren't too high, so the snow would get inside, making my feet wet and cold. We always had mittens, but some students didn't." (Courtesy of Brooklyn Historical Society.)

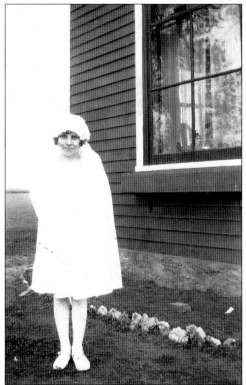

Here Martens wears a white taffeta first communion dress with lace along the yolk, a pin in the middle, and two bands of lace on the skirt. It was not hand sewn but from the catalog. In order to satisfy Fr. James Donahue's desire for modesty, dresses had long, puffy sleeves. Often outfits had matching bloomers or bloomers made of sugar or flour sacks with elastic at the waist. (Courtesy of Brooklyn Historical Society.)

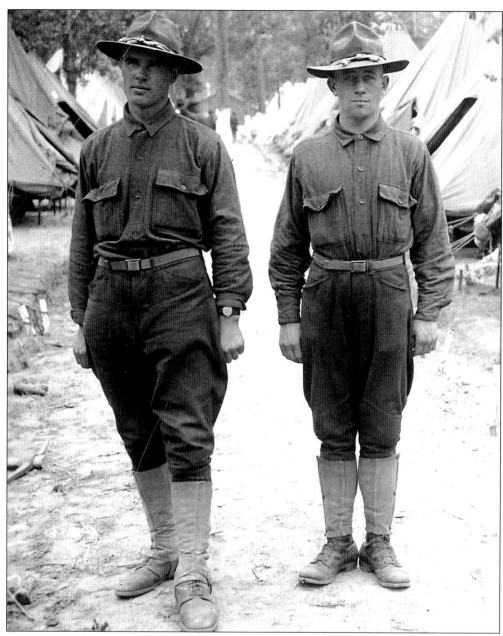

All too soon, World War I was upon the Brooklyns. The first men left for the Great Lakes training center. They included Nazyar Paul, Dan Larson, Charles Gossalein, and Otis Brown. Other men had already been drafted, and a farewell reception was prepared one evening at the Odd Fellows hall. New draftees included Bert Godfrey, Herbert Potvin, Dr. S. E. Dick, V. Duffey, Charles Killmer Jr., Charles Blake, Rude Peterson, Frank Bauermeister, Herman Kuehn, Ben Reinking, George Harves, Herman Kothrade, Stephen Glazer, and Henry Schmidt. The October 17, 1917, *Osseo Herald* issue read, "William and Louis Cardinal are in France and will begin receiving the paper." Gust Anderson answered the call and enlisted. In this April 15, 1918, photograph, he is at Camp Logan in Houston, Texas. (Courtesy of Rose Sandholm/Brooklyn Historical Society.)

Not all farmers enlisted because food was needed, but Uncle Sam required sacrifice at home. Newspapers promoted farmers and frugality: "Eat more poultry and eggs and help with the war." Another offered rabbit pie and sauce recipes: "Brer Rabbit has been drafted. His particular duty in the present war will be to permit himself to be eaten that more meat may be shipped to the soldiers." (Courtesy of Brooklyn Historical Society.)

MAKE VICTORY CERTAIN.

Food or defeat—that is the problem that confronts America. We must have abundant food to win this war. The Minnesota State Fair Food Training Camp, Sept. 3 to 8, through its machinery exhibits, will point out the way to obtain greater crop yields from the same land. Do your bit by showing your interest in this work. Attend the Minnesota State Fair.

The government went so far as to create a special set of recipes for rabbit. Housewives ran the Hoover Food Plan: "When we sit down to the family dinner . . . Uncle Sam now sits at the head of the World Dinner Table. . . . Mr. Hoover is asking him to apportion the dishes so that all his children shall get a square meal." Another article encouraged the sale of Liberty Bonds. (Courtesy of Osseo Preservation Society.)

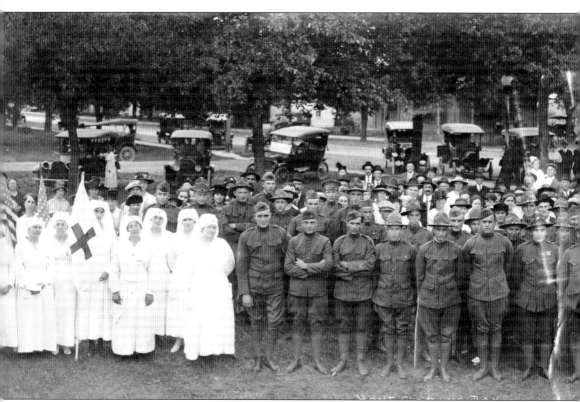

The newspaper promoted the Red Cross meetings: "The Red Cross met at the home of Mrs. Ferguson last Tuesday. There were twenty-two of the ladies and seven more present. Several of the men took their teams and large sleds and took the neighbors along the way, making the trip to and from the meeting an enjoyable one. The new members to join are E. W. Finch, Almeda Finch, Mrs. Guy Mattson, Mrs. Herman Goetze, Mr. and Mrs. Otto Schreiber, Mr. and Mrs. Casper Knobel, Mr. and Mrs. Henry Allan, Mrs. T. O. Robertson, Mrs. J. Bennett, Rob Riley, William Riley, Floyd J. Davis, Elva Dolley. . . . Come on in Long Prairieite, and make it the largest rural Red Cross Chapter in the country." They also posed with the "Sammies" when they returned home. (Courtesy of Osseo Preservation Society.)

Harry Setzler (pictured) and Arthur Smith enlisted. On August 2, 1916, Smith wrote, "We are well settled in [Llano Grande] Texas at last and expect to be here for some time. . . . It is 113 degrees Fahrenheit in the shade. . . . We were building streets and it was rather warm work. . . . We have been doing little drilling in the hot sun. Each man carries sixty rounds of ammunition with him in case of trouble." (Courtesy of Brooklyn Historical Society.)

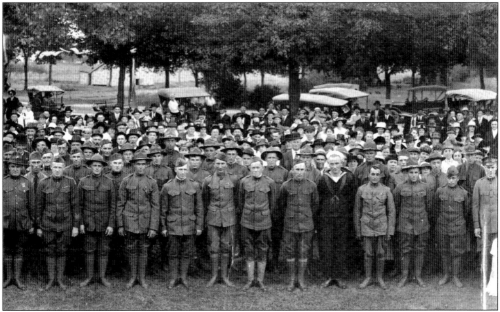

"The captains told the guards to shoot the first man who refused to obey their, 'Halt.' We haven't been having much to eat since we left Fort Snelling. . . . Three boys in my squad are broke buying food and the rest of us are very near it. We will not starve, anyway, until the money is all gone," wrote Arthur Smith. Plenty of food was served at this veterans' homecoming. (Photograph by Jeneen/Raymer Photography; courtesy of Osseo Preservation Society.)

The exceptional bravery of Brooklyn men continued into World War II, the Korean War, the Vietnam War, and in the Middle East. Norman T. Rochat is just one of many heroes. During World War II, after 30 successful bombing raids over Germany, Rochat's plane was shot down on March 21, 1945. As a prisoner of war, he lost a third of his weight, and he later received the Purple Heart. (Courtesy of Brooklyn Historical Society.)

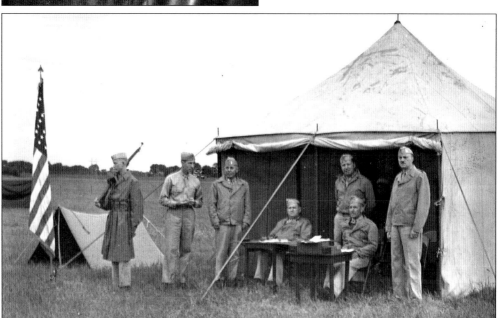

Preparations were taken on the home front. L. E. Paegel (pictured) of the Minnesota State Guard Company H camped at the Brooklyn Farm. Dozens of tents were erected over the field, and the men practiced. Ruth Howe Thiel remembered that in eighth grade she was excused from classes to assist in rolling bandages with the Brooklyn Center ladies under Ann Hamilton. Everyone did their part by rationing food, gas, and material. (Courtesy of Brooklyn Historical Society.)

# *Five*

# GROWING SUBURBS

By 1883, Minneapolis extended to Shingle Creek and Camden Township, communities that had a lot in common with Brooklyn Township. By the early 1900s, Brooklyn Center and Crystal Lake truck farmers feared annexation by Minneapolis. They met on February 14, 1911, at Earle Brown's garage (pictured) between 9:00 a.m. and 5:00 p.m. to vote. With 676 residents, the village of Brooklyn Center had 69 of the 83 qualified voters who favored incorporation. (Courtesy of Earle Brown/Brooklyn Historical Society.)

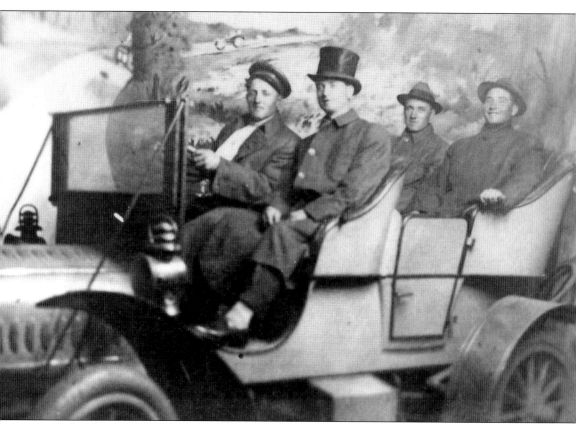

Early legislation included fines for dumping rubbish, defacing of the village highway, and shooting of firearms. Bans were placed on feeding garbage to hogs, playing billiards and cards, bowling, and ice-block houses. They wrote parameters for General Electric to run electricity and also expressed concern over the newfangled automobiles and motorcycles. Ordinance No. 3 read, "Any persons operating or driving any automobile or motorcycle on any public road in the said Village of Brooklyn Center at a greater speed than twenty miles an hour shall be guilty of a misdemeanor and upon conviction thereof shall be subject to a fine of not less than five dollars nor more than fifty dollars or imprisonment in the County jail." Posing above in a parked automobile are Julius and Adolphe Eidem with Severn Swanson and an unidentified person at the 1914 Minnesota State Fair. (Courtesy of Eidem family/Brooklyn Historical Society.)

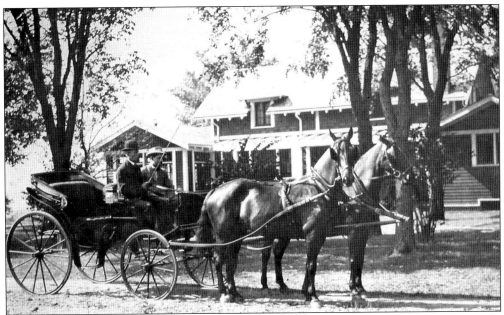

Along with the automobile came the problem of accidents and competing with horses for the same road. The July 18, 1917, *Osseo Review* covered a buggy and car collision where Maud Haviland "suffered a severe shock." In the same issue, "a party of automobilists . . . lost their left rear wheel from their car just north of the village hall." Above, Earle Brown is seated on the right. (Courtesy of Earle Brown/Brooklyn Historical Society.)

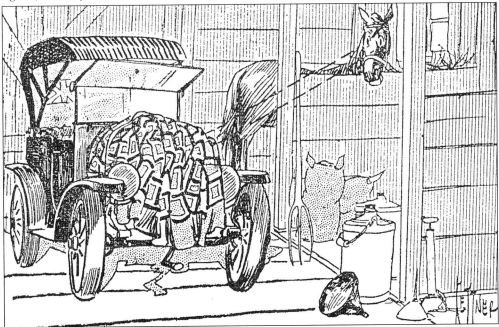

The novelty of automobiles was to last a long time, and old habits died slowly. The February 9, 1916, *Osseo Review* ran the following human interest story: "Geo. Fiske and H. C. Wiltmer walked to Minneapolis Wednesday to see the auto show, although they both own autos, they preferred walking." (Courtesy of Osseo Preservation Society.)

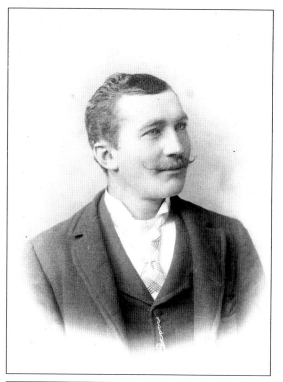

Following updates on Oscar Hartkopf's pneumonia and John Schreiber's remodeling, the February 27, 1913, *Osseo Review* had big news: "Herman Goetze [pictured] and Otto Schreiber are among the recent purchasers of automobiles in the vicinity. They have each a five-passenger car of the Veilie make, purchased of Matt Schaefer of Anoka." (Photograph by Miller Photography; courtesy of Audrey Hartkopf Alford/ Brooklyn Historical Society.)

# THEY'RE HERE!

## The 1915 Buick Valve-in-Head Cars —the Great Success of 1914

Everyone knows the BUICK as the car of Power and Speed. Everyone knows it is Durable and Reliable.

BUICK has proved itself so long and so thoroughly that it is the most popular car built.

Last season the entire output, 33,200 BUICKS, were sold early in March, and thousands of motorists were disappointed because they could not get a 1914 Buick.

Now's the time to place your order for a

# 1915

Buick Model C 24—The business man's ideal car. 4-Cylinder, 2 Passenger Roadster. Completely equipped, except speedometer, **Price, $900.00**

Buick Model C 25—Four Cylinder. Full sized Five Passenger Touring Car. Completely equipped, except speedometer. **Price, $950.00**

Along with automobiles came car theft. The *Osseo Review*'s August 2, 1916, issue ran the story of George M. Heesen, owner of the People's Cash store in Osseo. After only a few days, Heesen's Buick Six was stolen during his first trip to Minneapolis. Fortunately, the car was insured for both fire and theft and was found with the tires removed. Two youths awaited charges of larceny. (Courtesy of Osseo Preservation Society.)

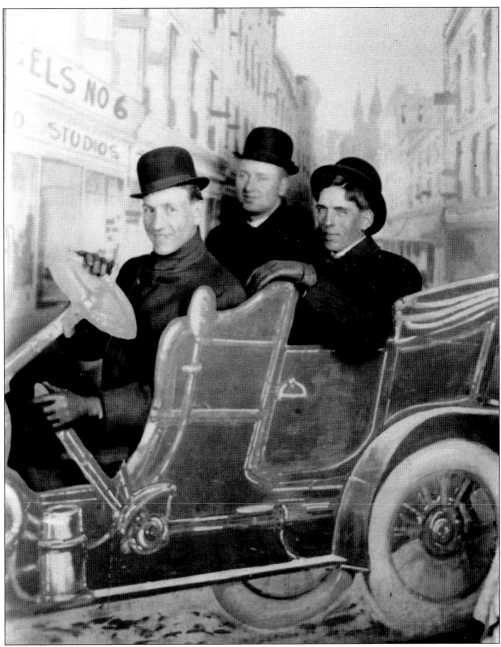

Old-timer Frank O'Brien wrote of the Minnesota State Fair, "I found there machinery for cutting, raking, loading, and also happy devices for baling, thus removing most of the discomfort. . . . All the farmer has to do now, is to seat himself . . . and hold a guiding line on his spirited team, while the ingenious mechanism in front and under and all about him does all the 'work,' from the grasshopper kickers of the rakes, comical enough to make a horse laugh, to the stackers and presses. Possibly at the next coming of the State Fair, I shall find that the services of the faithful horse have also been dispensed with, and that several farmers have clubbed together in the purchase of an 'automobile' with which to do the farm work." Here Christian Eidem tries out the automobile with a couple friends. (Courtesy of Brooklyn Historical Society.)

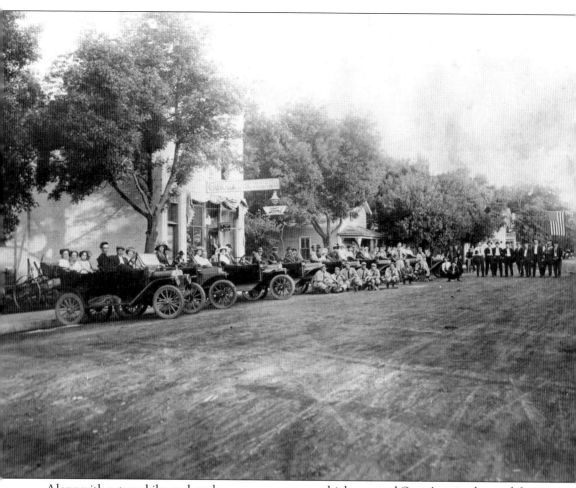

Along with automobiles and roads came concerns over highways and Osseo's main thoroughfare. By 1912, the Publicity Club of Minneapolis cited research that indicated farmers' savings by choosing markets accessible by the smoother roads with less wear and tear on their animals, produce, and equipment. By 1915 and 1916, automobile owners as well as farmers were calling for gravel and concrete roads to the tune of $2 million. In recent years, families or organizations adopted stretches of road to clean. The July 18, 1917, *Osseo Review* indicated Brooklyn's conservation. "The farmers living along the road from the Savage corner to the Smith schoolhouse were busy the first of the week, raking the road thoroughly to fill up the ruts and dispose of the large stones, and also mowed the grass and weeds on each side." (Courtesy of Osseo Preservation Society.)

After the automobile, the airplane became important. Local businessmen wanted World War I recruits prepared for service. After the secretary of the navy authorized Dunwoody Institute for aeronautics training, Earle Brown, as director of the Aero Club, offered free use of his 580-acre farm and buildings in February 1918. "Four obsolete, but somewhat regenerated JN4-A Curtiss aircrafts" were available for the 50 to 75 students to study their aeronautic skills. (Courtesy of Brooklyn Historical Society.)

Individual hangars were erected, and an observation platform was built from the top of one of the barns. By July, flight operations were opened to Midwest travel. At the close of the war, the government ordered the field closed. Years later, all that remained of the field was a propeller from a 1915 Curtiss JN-3 Jenny that hung in Brown's living room (pictured). (Courtesy of Earle Brown/Brooklyn Historical Society.)

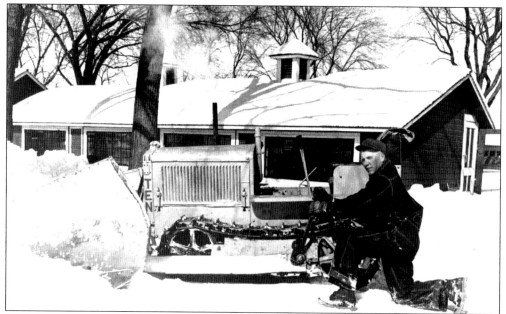

In 1932, Bob Cahlander earned 25¢ for making an arrest and was paid 10¢ a mile for travel. He also ran Brooklyn Center's first snowplow. Although it was more a Caterpillar tractor than a snowplow, he kept it in operation. By 1942, he made $150 per month by doing maintenance jobs, weed inspection, and street grading, along with being a constable and dogcatcher. Above, Carl Swing prepares the snowplow for work. (Courtesy of Earle Brown/Brooklyn Historical Society.)

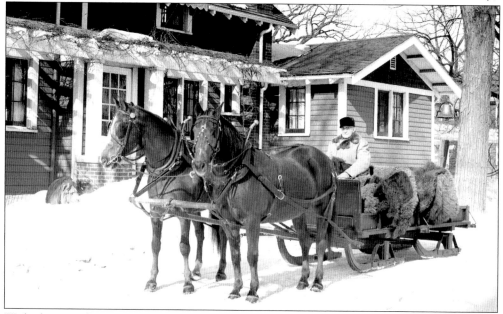

With the record snowstorms in the 1930s, clearing the roads of snow became a full-time job for Cahlander. However, farmers were not too happy. They preferred the snow-filled roads that accommodated their sleighs and were not ready for slippery roads. Brooklyn folks preferred the horse-drawn sleighs with the sleigh bells jingling over the fields to visit neighbors. Earle Brown poses here in front of his cottage. (Courtesy of Earle Brown/Brooklyn Historical Society.)

Progress continued to come to Brooklyn Township as pay stations were finally closed in Osseo in 1915. Booths were removed and connections were made to the switchboard of the local Rural Telephone Company, now connected to the Northwestern Telephone Company. Mildred Smith (left) and Myrtle Engles were switchboard operators in 1926. (Courtesy of Osseo Preservation Society.)

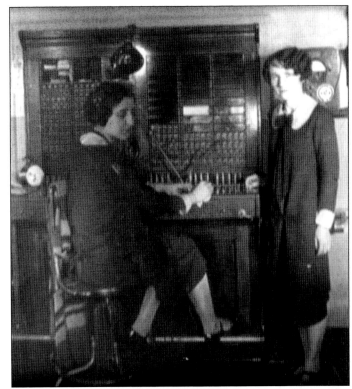

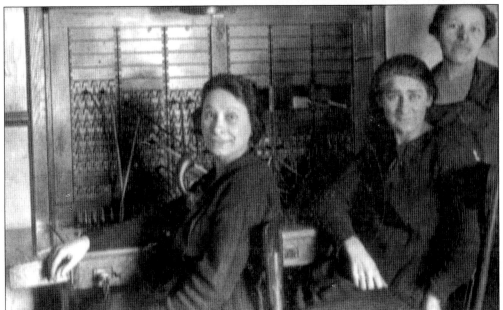

By connecting with the Northwestern Telephone Company, people in Osseo and outside subscribers of the Brooklyn area could now call direct over the tristate lines. They could now contact people in Minneapolis or St. Paul. A call to Minneapolis was 15¢ with a 1¢ war tax. From left to right, Lillian Killmer Robertson, Emma (Gosselin) Van Dyke, and Mamie (Wells Killmer) Phenow kept their neighbors connected. (Courtesy of Osseo Preservation Society.)

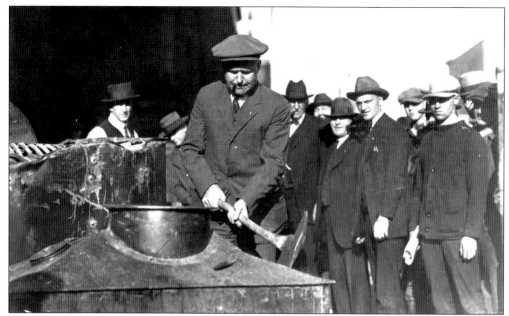

When Earle Brown took over as sheriff of Hennepin County in 1920 during Prohibition, corruption was everywhere. The Barker and Dilliger gangs gave Minneapolis and St. Paul a bad name. As the previous sheriff went to Leavenworth Prison, Brown began cleansing the county. His first step was to get rid of illegal stills (pictured), close down roadhouses, and purge the county of bootleggers. (Courtesy of Earle Brown/Brooklyn Historical Society.)

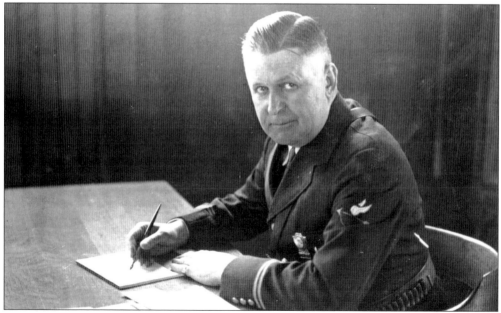

Brown's sidekick, Fend "Hammy" Hamilton, drove the duo to dozens of raids. Over the years, they made many friends and enemies. His chauffeur, Bill Hines, commented, "Earle [above] was never more than four feet from a gun. He had one in his desk, and kept a loaded gun under the dining table and behind the drapes near the door. A slanted mirror over his table gave him a rear view." (Courtesy of Earle Brown/Brooklyn Historical Society.)

In 1929, Minnesota began requiring individuals to enforce motor vehicle laws, except for speeding, on trunk highways. Gov. Theodore Christianson and commissioner of highways Charles M. Babcock talked Brown into the position. He resigned as sheriff and accepted the position of chief of the Minnesota Highway Patrol at half his previous salary. At his own expense, he converted E barn into a highway patrol assembly hall, classroom, and dorm for trainees. Richard Pursley appears on the far left. (Courtesy of Earle Brown/ Brooklyn Historical Society.)

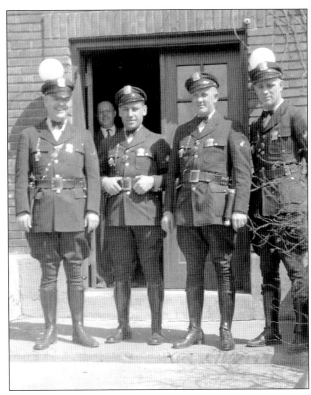

The first graduates camped in horse stalls with two double-decker bunks for every four men. Graduates learned geography, state traffic laws, first aid, how to make arrests, the care of firearms, and marksmanship with both the right and left hands. At $150 per month, the first eight graduates began monitoring highways in Minnesota's 87 counties. The early Model A went 60 to 65 miles per hour, and highway patrol cars became a patrolman's office. (Courtesy of Brooklyn Historical Society.)

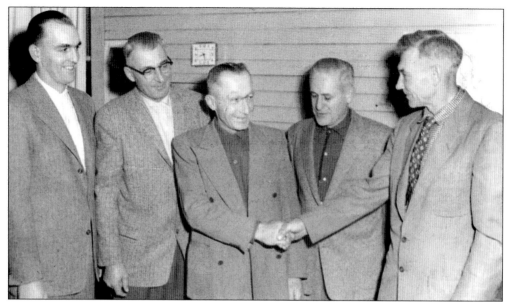

Baldwin "Baldy" Hartkopf pointed out that although Brooklyn farmers continued to conduct business in Osseo, they were nondrinkers. As Osseo grew and threatened Brooklyn Township's autonomy, the farmers voted to incorporate the Village of Brooklyn Park in 1954. From left to right are Al Joyner, clerk; Harry Schreiber; Abe Zimmerman, trustee; Hilmer Guntzel, trustee; and Baldwin "Baldy" Hartkopf, mayor, at a Brooklyn Park village council meeting in 1956. (Courtesy of Brooklyn Historical Society.)

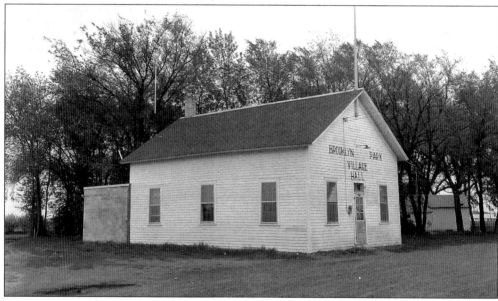

By 1966, voters selected a council-manager form of government, and three years later, Brooklyn Park became a charter city. This early Brooklyn Park Village Hall was previously the Brooklyn Township Hall, built in 1875. Today the city of Brooklyn Park covers approximately 17,020 acres with over 72,525 people. Although potatoes are no longer grown in Brooklyn Park, corn was harvested in 2008, and a roadside market still offered fresh produce. (Courtesy of Mary Blesi/ Brooklyn Historical Society.)

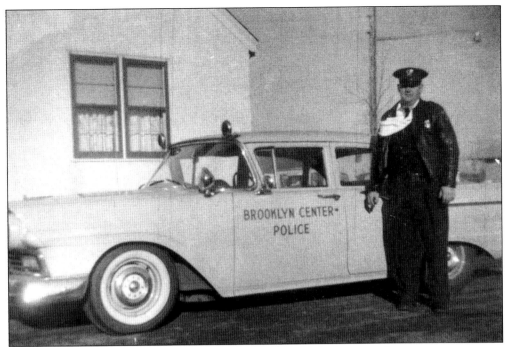

Brooklyn Center approved a city charter in 1966 and established a council-manager government. The federal census in 2000 identified a population of 29,172 people in Brooklyn Center, a city that covered eight and a half square miles. Brooklyn Center purchased its first police car with a two-way radio in 1952. Prior to that, officers' wives switched signal calls by turning on a house light. Later, when the siren tower was erected, "a light on the tower conveyed the same message." By 1958, Bob Cahlander was officially appointed chief. He and his assistant, Ellsworth Nelson (pictured above), could "hand rattle" check all businesses in 45 minutes. Pictured below is one of the early vehicles driven by Brooklyn Center's volunteer firemen. (Courtesy of Brooklyn Historical Society.)

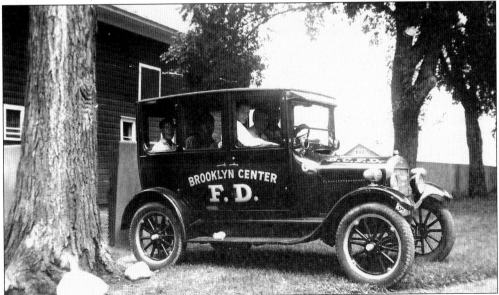

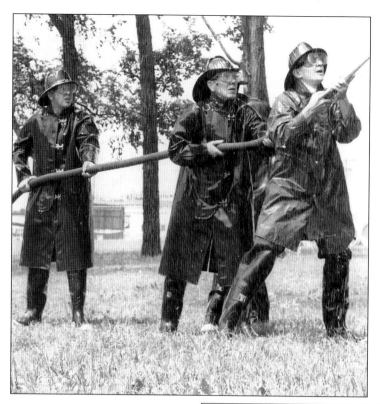

Brooklyn Center originally contracted with the Minneapolis Fire Department. When the annual bill became too expensive in 1949, the Brooklyn Center Fire Department was founded. Community involvement included whole families. Pat Keefe Rice recalls her mother declined serving coffee to firemen during a fire because she was in labor. From left to right, Jerry Cichoski, Don Mckinley, and Ken Persons participate in a firemen's local competition. (Courtesy of Tony Kueffler/Brooklyn Historical Society.)

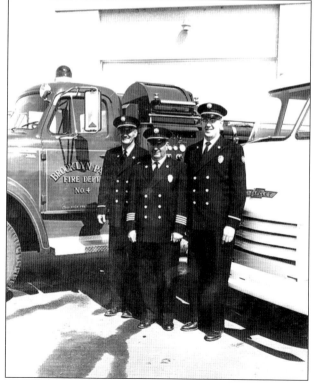

On April 10, 1957, the Brooklyn Park Volunteer Fire Department was founded. After a donation dance at the Riverlyn Club, a 1949 GMC truck chassis with an 800-gallon Standard Oil truck tank was purchased for $200. Next, they purchased the rig "Little Squirt" for $376.55. From left to right, volunteer firemen Bill Seemann, Orris Aldrich, and Don Holmberg stand in front of a 1960 fire truck. (Courtesy of Raymond Nordberg/Brooklyn Historical Society.)

When World War II ended, housing developments sprang up overnight. In 1947, the John and Grace Keillor family drove to Seventy-seventh Avenue North and West River Road to purchase property. With a GI loan, John Keillor built a Cape Cod bungalow. Garrison Keillor said of his Brooklyn Park childhood, "The pastoral qualities of Lake Wobegon—the innocence and freshness—really stem from Brooklyn Park, my boyhood home." (Courtesy of Brooklyn Historical Society.)

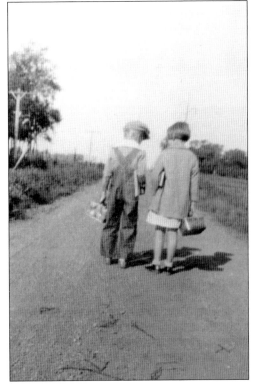

In 1932, Marlys (Eidem) Johnson and Bud Eidem (pictured) walk to school and fit Garrison Keillor's image of a fictional town where "all the women are strong, all the men are good-looking, and all the children are above average." Since Keillor attended school in Brooklyn Park, one would like to believe that strong women, good-looking men, and above-average children possibly describes the people of Brooklyn Park and Brooklyn Center. (Courtesy of Eidem family/Brooklyn Historical Society.)

# ACROSS AMERICA, PEOPLE ARE DISCOVERING SOMETHING WONDERFUL. THEIR HERITAGE.

Arcadia Publishing is the leading local history publisher in the United States. With more than 3,000 titles in print and hundreds of new titles released every year, Arcadia has extensive specialized experience chronicling the history of communities and celebrating America's hidden stories, bringing to life the people, places, and events from the past. To discover the history of other communities across the nation, please visit:

## www.arcadiapublishing.com

Customized search tools allow you to find regional history books about the town where you grew up, the cities where your friends and family live, the town where your parents met, or even that retirement spot you've been dreaming about.